Felting Fabulous Flowers

GILLIAN HARRIS

COLLINS & BROWN

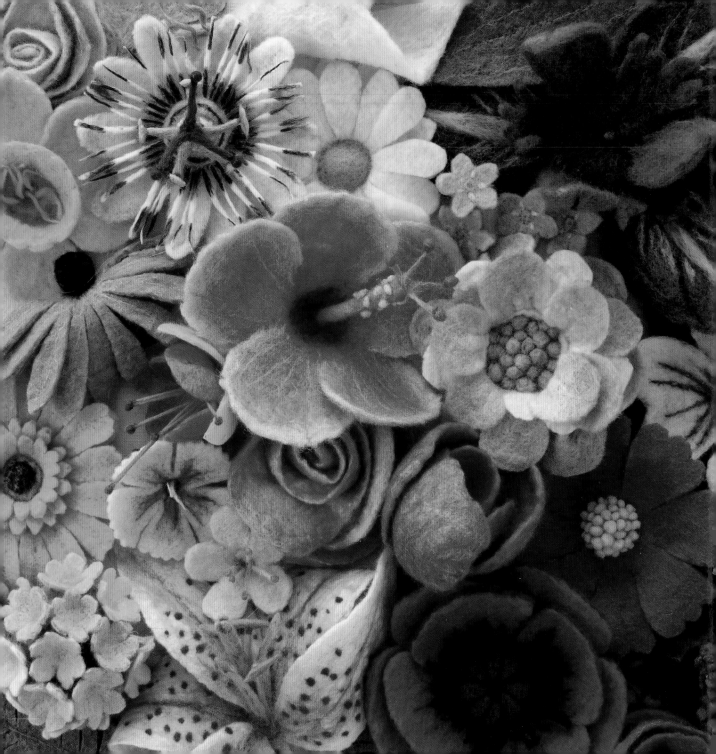

CONTENTS

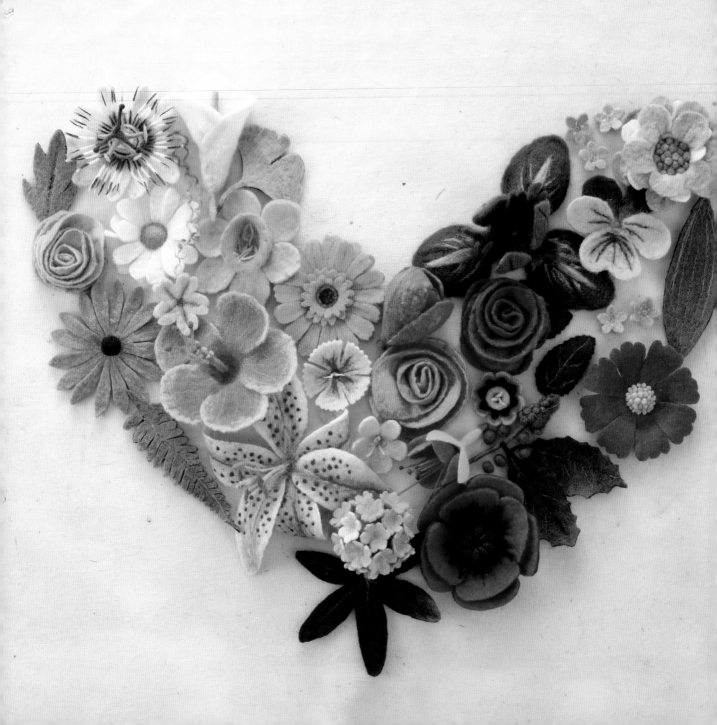

Felting Fabulous Flowers contains all the simple tips, tricks and techniques you need to create your own impressive colourful felted flower garden. From simple daisies and cherry blossoms, through to more intricate passion flowers and exotic hibiscus, I will guide you through how to make the felt, construct the flowers, and add the finishing final touches with stamens, pollen and leaves.

Use your freshly-made felt flowers to embellish, adorn and decorate everything in sight! There are so many opportunities to use everlasting woolly flowers – adorn a bag, make them into brooches and corsages, headpieces, tiaras, or just pop them in a vase. The possibilities are endless.

Born out of a love for all things floral, my enthusiasm for making felt flowers has grown from strength to strength. It is possible to make the most amazing felted blooms with some simple woolly ingredients, a bit of elbow grease and a few hours of your time.

This book is dedicated to my lovely late father Jack Harris, who was a constant source of inspiration when it came to Flora and Fauna in the garden.

Gillian Harris

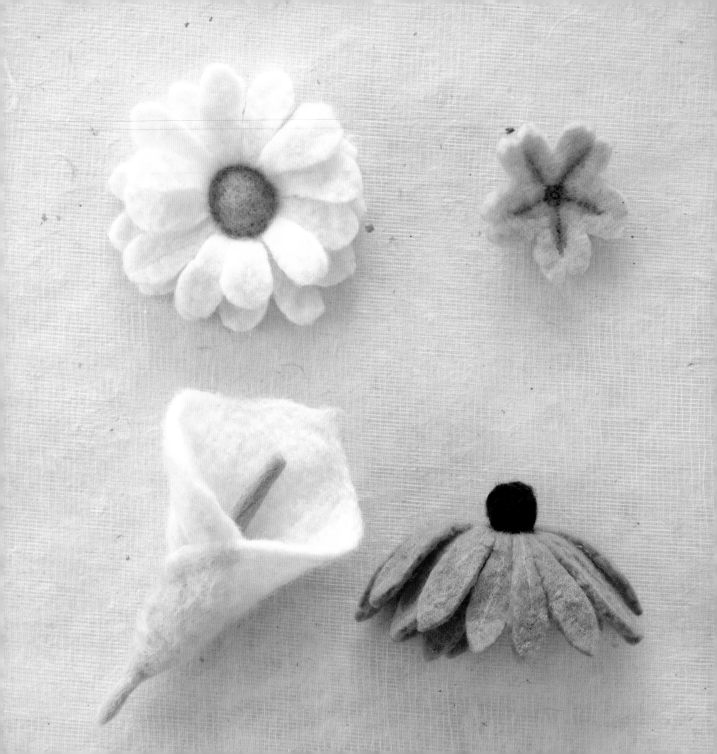

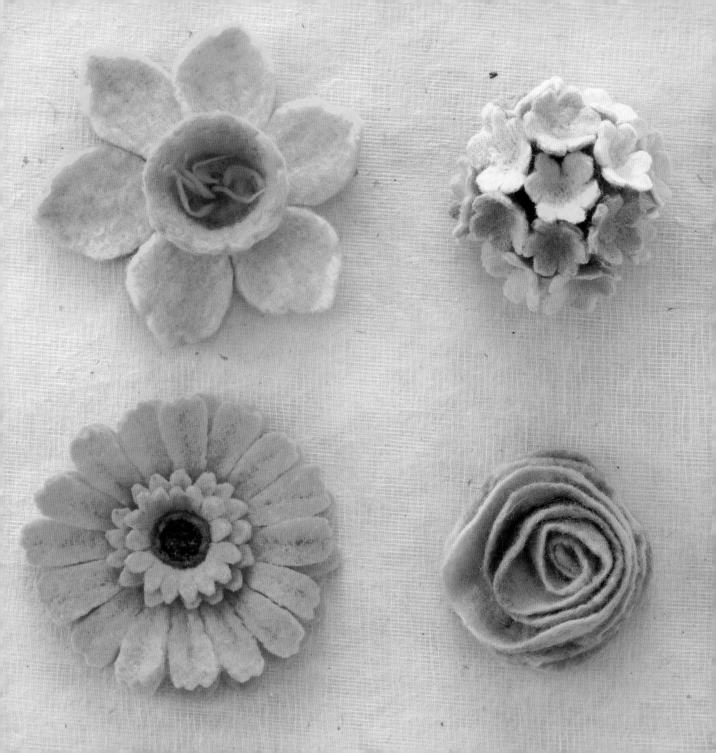

Daisy
Bellis perennis

MAKING THE PETALS

1. Referring to the method on page 70, start by making a square of white felt that measures at approx. 25cm (10in) square. You can use a sheet of ready-made felt instead, but the handmade felt will give you a better look and finish, and is more accepting of the new needle felted wool tops.

2. Referring to the template on page 79, cut two sets of daisy petals which will be layered one on top of the other.

3. Referring to the method on page 68, create subtle veins down the length of some of the top layer petals by needle felting tiny amounts of white wool tops from the base to the tip. This will make the petals look more interesting and realistic.

PIECING TOGETHER

1. Place one set of petals on top of the other, making sure they look realistic, with the petals alternating nicely.

2. Needle felt gold wool tops into a small circle in the centre. Bundle up a larger quantity of gold and bright yellow wool tops together – about the size of a frozen pea and start to needle felt this on top – to form a raised yellow dome in the centre of the flower. Keep needling until this is firm and solid.

Primrose
Primula vulgaris

YOU WILL NEED

Merino wool tops
30g (1⅓oz) pale yellow (or piece of pale yellow shop-bought felt) Small amounts of gold, olive and bright olive green for petal markings

Other requirements
Wet felting essentials
Needle felting essentials
36 and 38-gauge felting needles

(Easy)
Makes a few primroses

1. Referring to the method for wet felting a piece of flat felt on page 70, make a piece of pale yellow felt to end up measuring about 20cm (8in) square. (Alternatively you could use shop-bought felt, but the end result won't look quite as handmade. Also, the handmade felt accepts the needle felting better and is slightly more sculptural to work with.)

2. Using the template on page 80 as a guide, cut out the primrose shape from the pale yellow felt. The end of each primrose petal should look slightly heart shaped.

3. Referring to the technique for needle felting on page 68 and to add the markings, use a 38-gauge felting needle and small amounts of wool tops. Start by creating the markings on each petal. Use gold wool tops to add markings radiating out from the centre down each petal. This should roughly look like a fine star shape in the centre of the flower.

4. Now add olive green wool tops into the centre, and then brighter and lighter olive wool tops to the very middle.

5. At this point switch to a sturdier 36-gauge needle, if you have one, to indent the centre of the flower downwards.

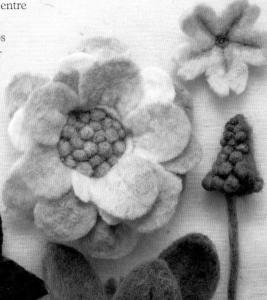

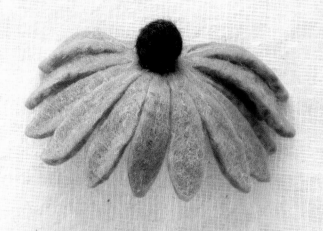

Rudbeckia
Rudbeckia hirta

YOU WILL NEED

Merino wool tops

20g (⅔oz) gold (or large square
of ready-made gold felt)
20g (⅔oz) bright yellow
10g (⅓oz) chocolate brown
Small amounts of bright yellow
and gold

Other requirements

Wet felting essentials
Needle felting essentials
38-gauge felting needle
Fabric stiffener

(Easy)

Makes a couple of
rudbeckia flowers

MAKING THE PETALS

1. Referring to the wet felting method on page 70, start by making a square of felt that measures approx. 25cm (10in) square. Use gold for one side of the felt and bright yellow for the other side. You can also use a sheet of ready-made felt instead, but the handmade felt will give you a more realistic look and finish and is more accepting of the new needle felted wool tops which get needled on top.

2. Referring to the template on page 77, cut one set of rudbeckia petals. With the flower gold side up, refer to the needle felting method on page 68 to add subtle veins down the length of the petals by needle felting tiny amounts of bright yellow in fine lines from the base to the tip of the petal. This will make the petals look more interesting and realistic.

3. Take a piece of brown wool tops about 5cm (2in) long and start to either wet felt or needle felt into a small ball which should end up about 1cm (½in) in diameter (see page 75).

4. Attach it to the centre of the flower using the single 38-gauge felting needle and a tiny amount more of the brown wool around its base.

FINISHING

1. Spray the flower petals with a fabric stiffener and mould to dry by placing the flower upside down into a cupped container or shuttlecock to bend back the petals a little.

2. Once dry, lift some of the petals from one another and cut as far down to the centre as you can, taking care that the cuts aren't too close to one another.

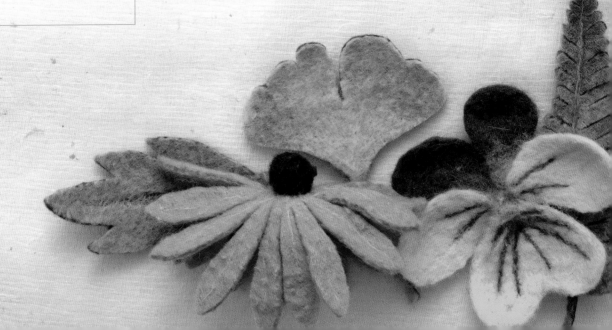

Calla lily
Zantedeschia aethiopica

YOU WILL NEED

Merino wool tops
30g (1⅓oz) white
20g (⅔oz) citrus green
10g (⅓oz) gold
Small amount of bright yellow

Other requirements
Needle felting essentials
Wet felting essentials
Foam
Strong fabric glue
Fabric stiffener

(Intermediate)
Makes one calla lily

MAKING THE CALLA LILY PETAL

1. Referring to the method for needle felting petals on page 66, and the calla lily petal template on page 76, lay out about 15cm (6in) of white wool tops onto some foam for the main calla lily petal. Needle felt together using a multi-needle tool, if you have one, for speed. Add a small amount of citrus green wool tops around the base. This petal should start being a rough oval shape measuring about 15cm (6in) high by 12cm (5in) wide and will shrink a little as it is needled together.

2. Turn the petal over and needle from the other side too. Keep needling until the petal feels well held together and has neat edges.

3. Referring to the technique on page 72, wet felt this petal. After all the soap has been removed, coat with a fabric stiffener.

4. Curl the petal up into shape by bringing the right-hand side over the left and leaving the slight point at the top.

5. Manipulate the petal whilst wet, and flare out the top into a trumpet shape. Bunch the base together – this will be needle felted together more later. Secure with a pin and leave to dry.

6. When dry, glue the two sides of the petal together and then leave to dry again.

7. Work the last cm or so at the base into a stem using a felting needle. Keep turning and needling – adding a further small amount of citrus green wool tops if necessary.

MAKING AND ATTACHING THE STAMEN

1. Referring to the method for making stamens on page 74, make the main stamen in the centre of the calla lily using gold wool tops with a little bright yellow wool tops mixed in with it. Make a large stamen that will end up measuring about 7cm (3in) long and about 5mm (¼in) wide.

2. When the flower and the stamen are completely dry put some strong fabric glue into the very base of the flower and stick the stamen in place. It should come to just underneath the top of the petal, so trim the end of it if it is too long.

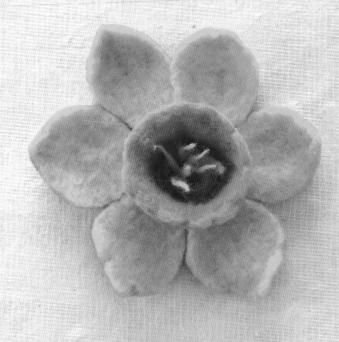

Daffodil
Narcissus pseudonarcissus

WET FELTING THE DAFFODIL

1. Referring to the method for wet felting a piece of flat felt on page 70, make a piece of bright yellow and orange felt to end up measuring about 25–30cm (10–12in) square. Make the main area yellow and add on an area of orange wool tops around the edge to make the daffodil trumpets. (Alternatively you could use shop-bought felt, but making your own gives you more interesting colours and edges.)

2. Using the template on page 77 as a guide, cut out the daffodil petals shape which has six petals.

3. Pull each petal out sideways to make it slightly wider so the six petals overlap each other a little.

4. Add interest to the petals by needle felting some fine lines down from the tip of each petal using a darker yellow or gold wool tops. You could also add a little darker wool around the edges of the petals too (see page 68).

MAKING AND ATTACHING THE DAFFODIL TRUMPET

1. To make the daffodil trumpet, cut a length of the orange felt measuring about 10cm (4in) wide and 2.5cm (1in) wide. It's the lovely finished frilly, slightly wavy, edge of the orange handmade felt that you're interested in. It will sit pointing uppermost.

2. Join the short edges of the piece together to make a cylinder using orange wool tops, needle felting them together with the wool over the top to form a seamless join. (Alternatively you could use fabric glue.) Working around a small piece of foam inside can be helpful.

3. Needle felt into the top edge of the finished cylinder every 5mm (¼in) or so, to create a slightly scalloped 'frilly' edge (see page 69). Stand the cylinder on it's top end and needle felt just around the outside edge to splay it out a little. It's also possible to make it flare out by pulling it gently. The idea is to make it trumpet shaped.

4. Tuck in the bottom edge of the cylinder underneath all the way round and pin into position on top of the petals using sewing pins. Needle felt firmly into position. Spend time needle felting from the inside and around the edge from the outside and add extra wool tops from the inside if necessary. It will gradually become more sculptural and you will be able to indent the base and the sides slightly as the wool becomes firmer.

5. Needle felt some yellow wool tops inside with a lime green centre.

MAKING AND ATTACHING STAMENS

1. Referring to the method on page 74, make three bright yellow stamens using bright yellow wool tops – about 13cm (5¼in) long.

2. Thread the finished stamens one by one through the eye of a large needle and feed them down through the centre of the daffodil and then back up again, so each long original stamen should form two finished stamens in the centre of the flower.

Lantana
Lantana camara

YOU WILL NEED

Merino wool tops

20g (⅔oz) sage (for ball in centre)
20g (⅔oz) candy pink
20g (⅔oz) salmon pink
15g (½oz) pale pink
15g (½oz) bright yellow
15g (½oz) pale yellow
Small amounts of peach, bright
yellow, orange for flower centres

Other requirements

Wet felting essentials
Needle felting essentials
Small sharp scissors
38-gauge felting needle
Fabric stiffener
Fabric glue
Pins

(Intermediate)

Makes one big lantana flower

MAKING ALL THE SMALL FLOWERS

1. Referring to the wet felting method on page 70, start by making a large rectangle of felt incorporating all the colours you will need. Simply lay the different colours out butting them up next to one another.

2. You will need to cut approx. eight candy pink; five salmon pink; four pale pink; two bright yellow and two pale yellow – although these are rough guides, and you can choose to make more of one colour than another if you prefer a slightly different look when finished. (Any combination of pinks, oranges and yellows will work well!) Ready-made felt can be used instead of handmade felt if you prefer.

3. Use small sharp scissors and the template on page 78 to cut the different colour flowers from the felt.

4. Referring to the method on page 67, Use a single 38-gauge felting needle and tiny amounts of wool tops to add a centre to each flower. In the candy pink and salmon pink flowers, add a small amount of bright orange, in the pale pink flowers add peach and bright yellow together, and in the bright yellow and pale yellow flowers add peach centres.

5. Coat each of the small flowers in fabric stiffening solution and mould in a slightly cupped shape using your thumbs.

6. Leave to dry.

MAKING THE LARGE GREEN BALL

1. Referring to the method on page 75, wet felt a large sage green felt ball, which should end up approximately 5cm (2in) in diameter. This will become the centre onto which all the flowers will sit and get attached.

2. Leave to dry

PIECING TOGETHER

1. Carefully place the flowers around the upper two thirds of the green ball using sewing pins to keep them in place. Start with the pinks around the base and work up through to the yellows in the centre.

2. Use the felting needle to add a further amount of wispy wool tops into the centre of each flower as you attach it to the ball. This is a little bit fiddly so take care not to squash the flowers you've already put in place.

3. Leaving the pins in place for now, squirt a small blob of clear drying fabric glue in between all the flowers to add further strength. You shouldn't see it once it's dry.

4. Leave the glue to dry, then carefully remove the pins.

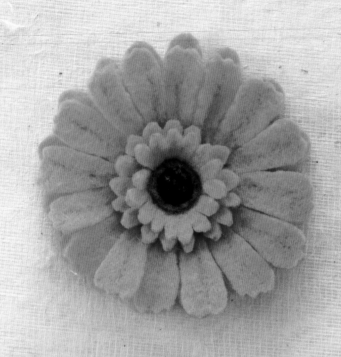

Gerbera

Gerbera jamesonsii

YOU WILL NEED

Merino wool tops

30g (1⅓oz) orange (or large square
of ready-made orange felt)
10g (⅓oz) pale yellow olive
Small amounts of brown and
rose pink

Other requirements

Wet felting essentials
Needle felting essentials
Pinking shears or serrated scissors
38-gauge felting needle

(Easy)

Makes one gerbera flower

MAKING THE PETALS

1. Referring to the wet felting method on page 70, start by making a square of felt that measures at approx. 25cm (10in) square using the orange wool tops. (You can also use a sheet of ready-made felt instead, but the handmade felt will give you a more realistic look and finish. It is also more accepting of the new needle felted wool tops which get needled on top.)

2. Referring to the template (1) on page 77, cut two sets of large gerbera petals.

3. Put one of these sets of petals to one side – these will sit underneath. Working on the upper set of petals, and referring to the needle felting method on page 68, use the rose pink wool tops to needle felt subtle veins down the length of each upper petal. Remember to use tiny amounts of wool. This will make the petals look more interesting and realistic.

4. Using a pair of pinking shears, or similar serrated scissors, carefully trim the end of each of these upper petals to give a zig zag edge.

5. Referring to the templates on page 77 (2 & 3), cut the two smaller inner shapes. One should be slightly bigger than the other. Either use the pinking shears again or follow the template guidelines carefully, using small sharp scissors, to achieve the detailed edges.

PIECING TOGETHER

1. Start with the lower larger petals. On top of these sit the other set of larger petals with the serrated edges and the petal detailing.

2. Finally, add the larger of the two centre parts and the smaller on top of that.

3. Use a 38-gauge felting needle and the pale yellow olive wool tops to needle all these sets of petals together. Use enough wool to form a slight dome shape in the centre, measuring no more than 1cm (½in) in diameter.

4. Finally, add some brown wool tops in the centre to indicate the pollen. This needn't be a complete circle. Refer to the picture and leave a few gaps to make the flower appear more realistic.

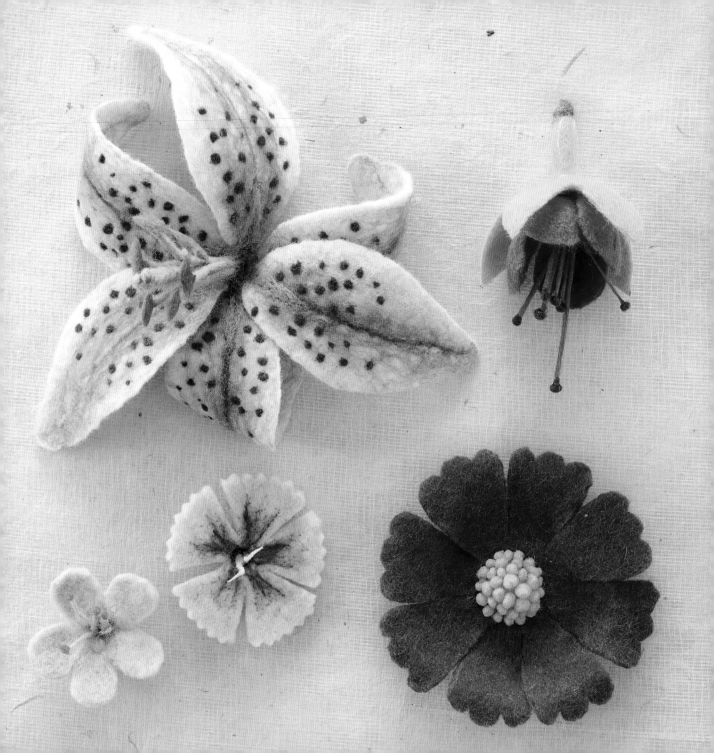

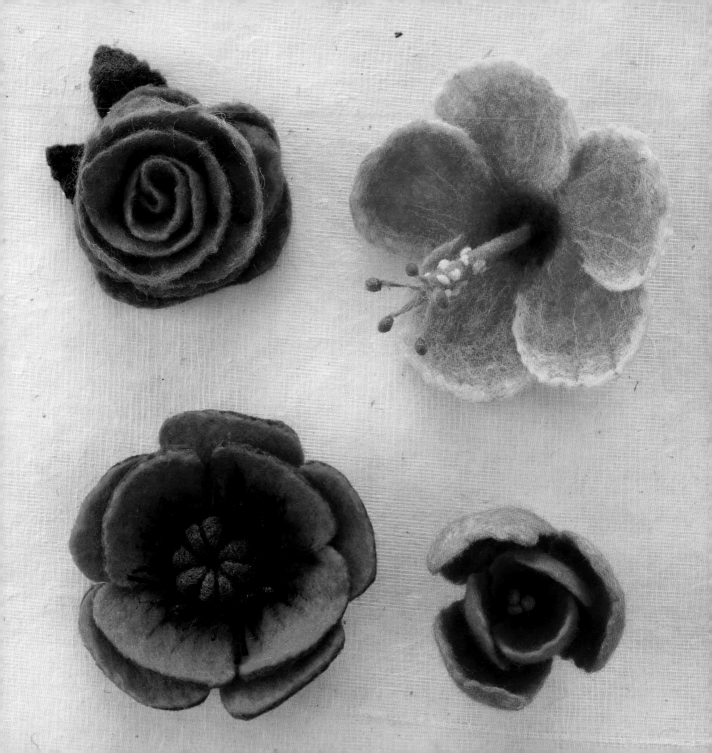

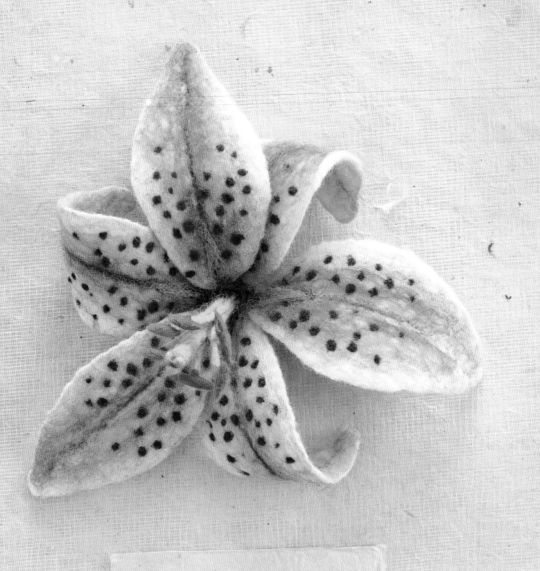

Stargazer lily
Lilium orientalis

YOU WILL NEED

Merino wool tops
30g (1⅓oz) white
20g (⅔oz) candy pink
20g (⅔oz) cherry red
20g (⅔oz) citrus green
10g (⅓oz) bright yellow
10g (⅓oz) lilac
10g (⅓oz) rust
Small amount of emerald green

Other requirements
Wet felting essentials
Needle felting essentials
Foam
Four-pronged needle felting tool
38-gauge felting needle
Strong fabric glue
Fabric stiffener
Small embroidery scissors

(Advanced)
Makes one stargazer lily

NEEDLE FELTING THE PETALS

1. Referring to the method for needle felting petals on page 66 and the lily petal template on page 77, lay out white wool tops onto some foam for the six stargazer lily petals. Each petal should be about two layers thick and measure about 14cm (5½in) in length.

2. Needle felt them one at a time using a four-pronged needle felting tool and 38-gauge felting needles (or similar). Once the six petals are more or less held together, remove them from the foam and put them straight onto a waterproof surface.

3. Add some very fine wispy pieces of candy pink wool tops over the main area of each petal, but leave white showing at the sides. Add a fine rose pink stripe down the centre of each petal and a little bit more at the base of each petal.

4. Wet felt these petals together as per instructions on page 72. The petals will shrink a little and the pink and red details will become fixed.

5. When dry, needle felt further details onto each petal using a single needle. If necessary, go over the line down the centre of each petal from the base to the tip using a little cherry red, then using extremely tiny pieces of cherry red, needle felt the tiny spots on each petal. These spots should be slightly more dense around the base of each petal.

6. Using the picture for reference needle felt some citrus green wool tops into an elongated triangle at the base of each petal about 2cm (¾in) long. Into each, add a small amount of bright yellow around the very edge of this and some emerald green right in the centre.

7. Coat the petals in a slightly diluted solution of fabric stiffener (I used Stiffen Stuff) and coil up loosely to dry. The three petals that will sit at the back should be slightly more coiled than the three at the front.

STAMENS AND POLLEN

1. Referring to the method for making stamens and pollen on pages 74 and 75, make the main stamen in the centre of the lily using citrus green wool tops with a little emerald green wool tops mixed in with it. Make a large stamen that will end up measuring about 6cm (2½in) long. Make this stamen wider and fatter at one end.

2. Make three extremely small pieces of pollen using lilac wool tops.

3. When dry, glue the three pieces of lilac pollen onto the top of the central stamen, using the picture as a guide.

4. Now make six slightly shorter green stamens using citrus wool tops. These should be about a quarter of the width of the main central stamen. It may be easier to make one very long stamen and then cut it into six pieces. Each of these stamens should measure about 5cm (2in) long.

5. To make the rust-coloured pollen that will sit on each of these six stamens, refer to the method for making pollen. Use rust-coloured wool tops and make six elongated pieces of pollen that measure about 1cm(½in) wide and taper at each end. Roll them between your fingers to get slightly more of a sausage shape and trim with some small embroidery scissors if necessary.

6. Leave the six pollen and the six stamens to dry and then carefully glue each piece of pollen onto the end of each stamen. Leave to dry.

7. Arrange the six smaller stamens/pollen around the larger central stamen and glue together about two-thirds of the way down. Leave to dry.

PIECING TOGETHER

1. Referring to the picture, take the six lily petals and start to arrange them with the newly-made central stamen in the centre.

2. This is a bit fiddly, but working on some foam, start by needle felting together three of the lily petals that will sit behind. Use some citrus green wool to do this, then place the three upper petals over the top and the stamen in the centre. Add further citrus green wool around the base of the central stamen and through the petals until everything is well held together.

3. Arrange the petals and recoil the back petals a little to make it look more realistic.

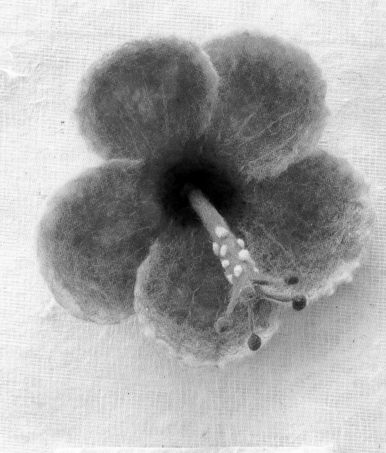

Hibiscus
Hibiscus rosa-sinensis

YOU WILL NEED

Merino wool tops

20g (⅔oz) each bright yellow and
rose pink for flower petals
5g (¼oz) cherry red for base
of petals
5g (¼oz) rose pink for stamen
Small amounts of bright yellow
and bright red for pollen

Other requirements

Wet felting essentials
Needle felting essentials
Foam
Multi-needle tool
Small sharp embroidery scissors
Strong fabric glue
Tweezers
Pins

(Advanced)

Makes one hibiscus flower

MAKING THE PETALS

1. Referring to the template on page
78, start by laying out wisps of bright
yellow wool tops into one petal shape
directly onto a piece of foam. It should
measure about 10cm (4in) long and
7cm (3in) wide. Add a rose pink
centre. Keep alternating the colours
wispily to achieve a subtle graduation
between the two, but keeping the
edges mostly yellow.

2. Referring to the needle felting
method on page 69 and using a
multi-needle tool, needle felt the wool
together a little, first from one side,
then turn it over and needle from the
other side too. Add more wool on
top if it's a bit thin in places and keep
alternating between the two colours to
create a subtle feathered effect. Add
a cherry red throat to the petal using
one felting needle, and delicate veins
in rose pink going from the top to
the bottom of the petal. Repeat this
process for another four petals – so
you have five in total.

3. Now wet felt the petals as per the
method on page 72. Once this is done,
each petal should measure about 7cm
(3in) long by about 5cm (2in) wide
and will feel more compact. Add
further veining onto each one with a
felting needle if necessary.

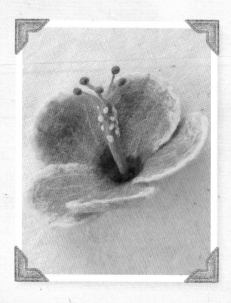

4. Needle the edge of the petals to
make them more 'frilly' (see page
69) and realistic so they aren't too
even and uniform. Shape each petal
a little by needle felting just under
the outside edges into the middle so,
as you needle into it, the outer edge
curves up a little bit to make the petals
slightly more cupped in shape (see
page 68). Put to one side whilst you
make the stamen and the pollen.

MAKING THE STAMEN AND POLLEN

1. Start with a piece of wool that's slightly longer than you need as it can always be trimmed down a bit, plus you are going to split one end of it into five equal parts to make the mini stamens for the red pollen to sit on. It's helpful to twist the dry wool tightly between your fingers to get an idea of the size it will be once wet felted. I'd recommend using a piece about 12cm (5in) long and about half the width of regular wool tops – in rose pink.

2. Wet felt this length together referring to the method on page 74. It's important that it's really well felted, so don't skimp on the rubbing and rolling and use plenty of soap!

3. When it's well felted and nearly finished, use small sharp embroidery scissors to split one end into five equal parts about 1cm (½in) long, creating the five mini stamens. Continue to felt these mini stamens with plenty of soap until each of them feels well felted too. Rinse until soap free and leave to dry.

4. Using tiny tufts of the bright red wool tops, roll five equal-sized felt balls measuring about 4mm (¼in) wide (see page 75). Then make about 12–15 even smaller bright yellow balls that are about 2mm (⅛in) wide. Wet felt all the balls – they don't take long. Leave to dry.

5. Glue the tiny yellow balls randomly around the top of the stamen under the five mini stamens, and then glue the five red balls onto each mini stamen end. This can be quite fiddly so you may want to use tweezers and some really good strong fabric glue. The felt balls don't weigh much so shouldn't be too much of a problem. Leave the glue to go a little more tacky if you are having problems.

6. Prop the stamen up somewhere to dry (you could peg the base of it to something to keep it upright).

PIECING TOGETHER

1. Using small sewing pins, carefully pin the five petals together towards the base with one overlapping the next. Make sure the fifth petal overlaps the first petal. Start to needle felt them together at the throat (see page 69). There should be a hole in the centre for the stamen to go through.

2. Insert the finished stamen through the hole in the centre, and then add some more cherry red around it and at the throat of each petal. (Pull apart the length of the wool to make the fibres much shorter so the red doesn't come up too high.)

3. As you needle felt into the throat it should draw the throat down and shape it, making the petals come outwards. This will give definition and shape, making it look less flat. Use the edge of the foam here, so the stamen hangs down the side of the foam whilst you work on the throat and the base of the petals.

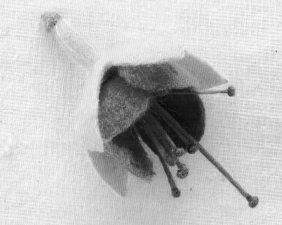

Fuchsia
Fuchsia spp.

YOU WILL NEED

Merino wool tops
20g (⅔oz) candy pink
20g (⅔oz) rose pink
10g (⅓oz) citrus green
Small amounts of cerise
and brown

Other requirements
Wet felting essentials
Needle felting essentials
38-gauge felting needle
Fabric glue
Fabric stiffener
Tweezers
Foam

(Advanced)
Makes one fuchsia

MAKING THE PETALS

1. Referring to the wet felting method on page 70, make two pieces of flat felt two layers thick – the first piece candy pink and the second piece rose pink. Each piece should measure about 20cm (8in) square. Leave to dry.
2. Using the templates on page 76, cut out the four-petalled shape (1) from the candy pink felt and the four separate petal shapes (2) from the rose pink felt.
3. Using a single 38-gauge felting needle, add some fine delicate veins on the outer side of the candy pink shape using citrus green wool tops.
4. Follow this by adding a single vertical vein down each darker pink separate petal using cerise wool tops. Make all these veins very fine and hardly use any wool, otherwise the effect won't be subtle or realistic.

MAKING THE SEED POD/TUBE

1. To make the seed pod that sits on top of the four outer petals, wet felt a short fat stamen in candy pink, referring to the method on page 74. Try to make it bulge out in the middle a bit more by wrapping a little extra wool around the middle before you wet felt it.
2. Make a similar, but much shorter, version in citrus green. Leave both to dry, then cut the end of both of these shapes and glue together. Leave to dry.
3. Join the bottom of the pink seed pod to the top of the candy pink four-petalled shape by needle felting small amounts of more candy pink wool tops around the base of it. Make sure it is completely central in the middle of the shape. Keep needling together until it holds and feels securely attached.
4. Coat all the petals in fabric stiffener and leave to dry. Leaving the petals to dry on something curved, such as a small ball, will result in a domed shape. Do the same with the four smaller petals – this will make the finished flower look far more realistic (see page 68).

MAKING THE STAMENS

1. Referring to the method on page 74, make one long rose pink stamen a few mm wide and about 25cm (10in) long. When well felted, coat in fabric stiffener and leave to dry.
2. Make about eight small pieces of brown pollen a few mm in diameter. Leave to dry.
3. Cut the long stamen up into one 4cm (1½in) stamen (the main central stamen or 'style') and six or seven shorter stamens each about 3cm (1¼in) long.
4. Glue a piece of brown pollen onto the end of each stamen. This is fiddly – use a pair of tweezers if it helps and prop them upside down to dry.

PIECING TOGETHER

1. Take the four separate smaller petals and cup them together with each petal overlapping. The more pointed part of the petals should all be together at the top. Put this part onto some foam and carefully needle felt this end together, using a little more rose pink to help if necessary.
2. Place these joined four petals into a small mould – something like an eggcup would be ideal – and put a large blob of glue in the centre. Put the wrong end of each stamen into the glue – keeping the longest stamen fairly central. Leave to dry.
3. Finally, remove this glued section from its mould and glue the top of it into the lighter pink four-petalled shape with the seed pod on top. Use the picture for reference.

Cherry blossom
Prunus serrulata

YOU WILL NEED

Merino wool tops

30g (1⅓oz) pale pink (or piece of pale pink shop-bought felt)
Small amounts of candy pink, pale yellow olive and rose pink for petal markings and stamens

Other requirements

Wet felting essentials
Needle felting essentials
Small sharp scissors
36 and 38-gauge felting needles
Strong fabric glue
Tweezers

(Easy)

Makes a few cherry blossom flowers

WET FELTING THE CHERRY BLOSSOM FLOWERS

1. Referring to the method for wet felting a piece of flat felt on page 70, make a piece of pale pink felt to end up measuring about 20cm (8in) square. Alternatively you could use shop-bought felt, but the end result won't look quite as handmade. Also, the handmade felt accepts the needle felting better and is slightly more sculptural to work with.

2. Using the template on page 80 as a guide and small sharp scissors, cut out a cherry blossom shape from the pink felt.

3. Referring to the technique for needle felting on page 68 and to add the markings, use a 38-gauge felting needle and small amounts of wool tops. Start by adding an approx. 1cm (½in) circle of candy pink into the very centre of the flower. Now add a smaller amount of rose pink into the centre of that. Switch to a sturdier 36-gauge needle to indent the centre of the flower downwards.

MAKING THE STAMENS

1. Referring to the method on page 74, make three pale yellow olive stamens using pale yellow olive wool tops – each about 10cm (4in) long.

2. Thread the finished stamens one by one through the eye of a large needle and feed them down into the very centre of the cherry blossom and then back up again, each strand forming two stamens. Repeat this with the other two. You should end up with five or six stamens pointing upwards. If necessary, trim these to approximately the same length so that they aren't too long.

3. Next make the pollen to sit on top of each stamen. For each stamen you will need to wet felt a tiny rose pink ball, measuring no more than a couple of mm each. Use tiny amounts of wool tops and roll together with soapy water and soap between your fingers. Rinse once felted and leave to dry (see page 75).

4. Use a strong fabric glue that dries clear to carefully stick a little pollen ball onto the top of each stamen. Use tweezers to place them correctly if you find this helpful!

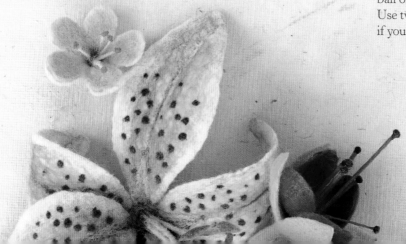

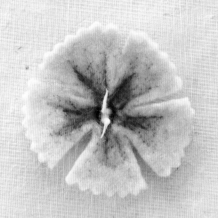

Dianthus
Dianthus chinensis

YOU WILL NEED

Merino wool tops

30g (1⅓oz) pale pink (or piece of pale pink shop-bought felt)
Small amounts of rose pink, grass green and white for petal markings and stamens

Other requirements

Wet felting essentials
Needle felting essentials
Pinking sheers
Small sharp scissors
36 and 38-gauge felting needles
Strong fabric glue (optional)
Fabric stiffener (optional)
Pins

(Easy)

Makes a few dianthus flowers

WET FELTING THE DIANTHUS

1. Referring to the method for wet felting a piece of flat felt on page 70, make a piece of pale pink felt to end up measuring about 20cm (8in) square. Alternatively you could use shop-bought felt, but the end result won't look quite as handmade. Also, handmade felt accepts the needle felting better and is slightly more sculptural to work with.

2. Using the template on page 76 as a guide, cut out a dianthus shape from the pink felt. You will need pinking sheers to cut the circle and then small sharp scissors to cut out slits and create each of the five petals.

3. Referring to the technique for needle felting on page 68 and to add the markings, use a 38-gauge star felting needle and small amounts of wool tops. Start by creating the markings on each petal. Use rose pink wool tops to add markings radiating out from the centre down each each petal, making them fade out slightly after they get halfway down. These flowers vary enormously, and different varieties have all manner of different markings, so don't worry if yours look slightly different to the picture!

4. Now add grass green wool tops into the centre. Switch to a sturdier 36-gauge needle to indent the centre of the flower downwards.

MAKING AND ATTACHING THE STAMENS

1. Referring to the method on page 74, make two white stamens using white wool tops – each about about 5cm (2in) long.

2. Thread the finished stamens one by one through the eye of a large needle and feed them up through the very centre of the dianthus. Adjust each stamen to length (not too tall but leave enough for the next bit) and secure underneath with a knot or some glue.

3. If you have some, use a stiffening solution or a watered down transparent glue to coat each stamen and fold back the very tip. Pin to hold until dry then remove the pins and the stamens should stay in place.

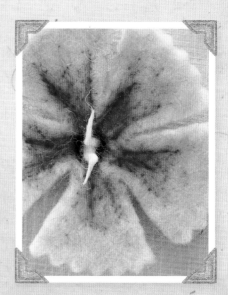

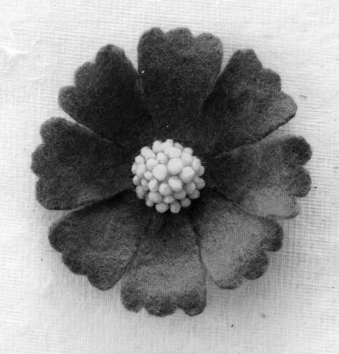

Cosmos
Cosmos bipinnatus

YOU WILL NEED

Merino wool tops
20g (⅔oz) red
20g (⅔oz) cerise
10g (⅓oz) bright yellow

Other requirements
Wet felting essentials
Needle felting essentials
Fabric stiffener
Strong fabric glue
Tweezers

(Easy)
Makes one big cosmos flower

MAKING THE FLOWER PETALS

1. Referring to the wet felting method on page 70, start by making a large rectangle of felt measuring about 20cm (8in) square, using the red for the first layer and cerise for the second layer. Leave to dry. Ready-made felt can be used here instead, but there will be less depth of colour and the look will be different at the end.

2. Using the template on page 79, carefully cut out the shape of the eight-petalled flower from the felt, paying particular attention to the shape at end of each petal.

3. Coat the flower in fabric stiffener and shape to make slightly more interesting. A cupped shape in the middle, with the petals bending back a little towards their ends, looks more realistic.

4. Leave to dry by pressing gently into a mould or small cup/eggcup to help keep its shape.

MAKING THE CENTRE

1. Referring to the method on page 75, wet felt a bright yellow ball measuring just over 1cm (½in) in diameter. Leave to dry then cut in half.

2. Stick one of the halves into the centre of the flower and leave to dry.

3. Meanwhile, in the same way, make about 40–45 tiny bright yellow balls that measure approx. 5mm (¼in) in diameter. Again, leave to dry.

4. Perhaps using tweezers to help you, carefully glue a ring of small balls around the outside of the central ball. Then continue to cover the large yellow ball in the smaller ones. Leave to dry.

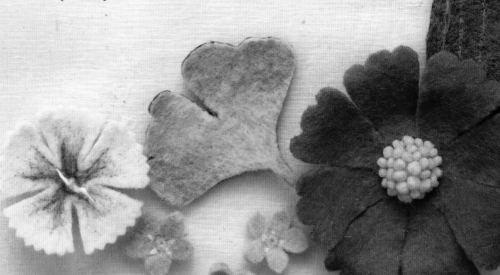

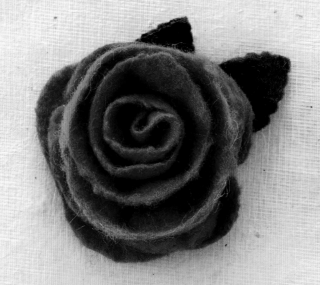

Rose
Rosa moschata

YOU WILL NEED

Merino wool tops
20g (⅔oz) each of two different colours (red and pink or yellow and gold etc.)
Small amount of a highlight colour for petal edges

Other requirements
Wet felting essentials
Needle felting essentials

(Intermediate)
Makes one large rose

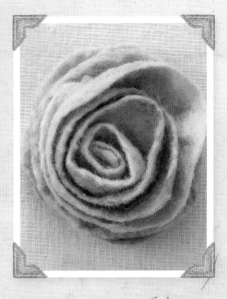

MAKING THE FELT PIECES
1. Referring to the method for wet felting a piece of flat felt on page 70, make a square of felt measuring 25–30cm (10–12in). Whichever colours you go for, choosing two variations of the same colour will result in the most realistic looking rose. Choose, for example, bright red and cherry red or pale pink and salmon pink.
2. When laying out the wool, measure a rectangle of one colour of fibres about 30cm x 20cm (12 x 8in). Add a slightly finer layer of the second colour on top in the opposite direction. Finish by adding highlights or lowlights of different colours around the very edges of the wool if desired.

3. Once made and dry, cut off the very outside edge of the felt rectangle in one continuous piece, no more than 2.5cm (1in) deep.
4. Now cut two random wavy and vaguely circular shapes from the remaining felt in the centre, making each about 10cm (4in) in diameter. Make one a slightly different shape from the other and cut them on the large size as they will be trimmed down later on. Place them on top of one another so that one sticks out slightly from under the other.

PIECING TOGETHER
1. Loosely coil the edge you have cut off. Start with a tighter 's' shape in the middle (just like the centre of a real rose) and then coil the rest up with plenty of space in between each coil - it shouldn't look like a tight Swiss roll! Place the coil on top of the cut shapes, making sure that the uncut edge is pointing upwards. This is your lovely frilly finished edge that will make the rose petals look more realistic.
2. Needle felt the very base of the coil onto the cut shapes below, stabbing the felting needle through the base of the coil and working from the outside right around the whole thing to the very inside at the centre (see page 69).
3. Once the coil is held fast, get a matching thread and sew tiny fairy stitches around the base of the coil. Again, start at the outside and work your way to the centre.
4. Needle felt the petals further to add more dimension to the rose.

You can sculpt the petals and get them to change shape and protrude by needling at the base of each. It's possible to add a little more wool at this point too, if necessary. Keep needle felting until the rose looks well shaped and is well held together.
5. Finish by trimming the original felt shapes at the base. They should match the shape of the rose by just sticking out from underneath as extra base petals.

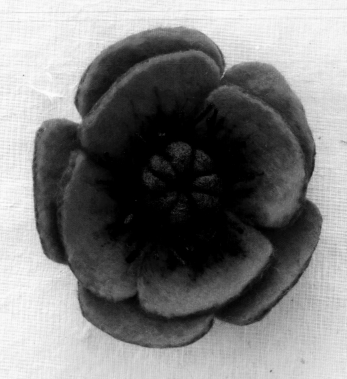

Poppy
Papaver rhoeas

YOU WILL NEED

Merino wool tops
20g (⅔oz) bright red (or piece of ready-made red felt)
20g (⅔oz) cherry red
20g (⅔oz) black
20g (⅔oz) smoke

Other requirements
Wet felting essentials
Needle felting essentials
36 and 38-gauge felting needle
Strong fabric glue
Fabric stiffener

(Intermediate)
Makes one poppy

MAKING THE PETALS

1. Referring to the wet felting method on page 70, start by making a rectangle of felt that measures approx. 30 x 20cm (12 x 8in), laying cherry wool tops in one direction and the brighter red wool tops in the other direction over the top.

2. Once dry, cut the two shapes for the poppy, using the templates on page 76, then place the four-petalled shape (1) on top of the five-petalled shape (2).

3. Using small wisps of black and smoke wool tops, needle felt some poppy markings onto the four front petals – radiating out from the centre. Keep needling into the centre area to attach the two sets of petals together and make the flower more cupped and realistic looking.

MAKING THE POPPY CENTRE

1. Using smoke wool tops, wet felt the central ball until it measures about 2.5cm (1in) in diameter (see page 75). Leave to dry.

2. Using a single 38-gauge felting needle, use black wool tops in very small amounts to create the four lines that go across the ball. Keep needling these in to create eight evenly spaced segments that will represent the centre of the poppy. This can take a little while to achieve – so persevere!

3. Attach the base of this central ball into the centre of the petals using the felting needle and/or a blob of glue. Leave to dry.

MAKING THE STAMENS

1. Referring to the method on page 74, make approximately 16 stamens, each measuring about 15cm (6in) long. Coat each one in a fabric stiffener and leave to dry.

2. Thread each stamen through the eye of a largish needle. Sew them down and then up again. Each long stamen that you've made will result in two stamen ends around the poppy centre. Continue all the way around until the central ball is surrounded by black stamens.

3. If necessary, trim the ends of the stamens to roughly the same length, so that they just poke out above the central ball.

4. Finally, take the larger 36-gauge felting needle and sculpt the shape of the flower further by needling into the petals, just around and under the stamens.

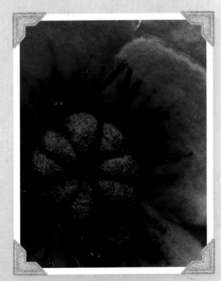

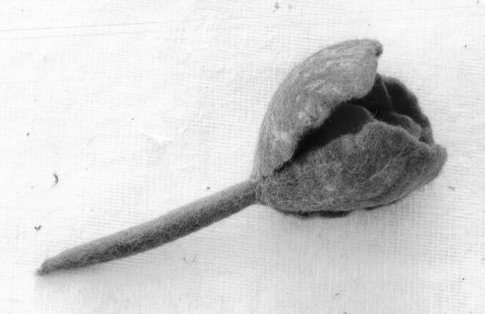

Tulip

Tulipa var.

YOU WILL NEED

Merino wool tops

30g (1⅓oz) red (or piece of
ready-made red felt)
10g (⅓oz) each emerald green,
gold, and pale yellow for markings
10g (⅓oz) bright yellow for pollen
15g (½oz) emerald green for stem

Other requirements

Wet felting essentials
Needle felting essentials
38-gauge felting needle
Fabric stiffener
Strong fabric glue
Needle and thread

(Intermediate)

Makes one tulip

MAKING THE PETALS AND STEM

1. Referring to the wet felting method on page 70, start by making a rectangle of felt that measures at approx. 30 x 20cm (12 x 8in) laying just red wool tops for one half and adding decoration up vertically on the other half using very fine wisps of emerald, gold and pale yellow to indicate some parrot flower markings. These markings are optional, but make the finished flower look more interesting.

2. Referring to the templates on page 80, cut three slightly smaller tulip shapes (1), and three slightly larger ones (2). Add further detailing to the outer three larger shapes using a single 38-gauge felting needle and tiny amounts of the emerald, gold and pale yellow wool tops.

3. Continue with the felting needle, making sure the edges of the six petals don't look too even. Carefully stab sideways into the petals to create indentations and ripples to make the tulip look more realistic with slightly frilly-edged petals.

4. Once you are happy with the way the petals look, wet felt them all again. This will make the cut edges tighter and will allow you to shape them further. As you rub each petal with the soap, use your thumb to make them slightly more cupped in appearance.

5. Remove all the soap, then coat each petal with some fabric stiffener. Shape further, cupping each petal as much as possible, then leave to dry. It is helpful to push them down into a small mould, such as an eggcup or shuttlecock, to help keep their shape as they dry. The curved shape of the petals is really important and having them as cupped as possible will help assembly later on.

6. Referring to the method on page 73, make a stem for the tulip measuring about 8mm (⅓in) wide and as long as you want it.

7. Leave everything to dry.

PIECING TOGETHER

1. Start with the undecorated smaller three petals. Cup the undecorated smaller three petals together in your hands, overlapping each one so that they form a tulip shape. Apply a small blob of glue in between the petals to hold them together. Leave to dry.

2. Insert the stem up through the hole in the middle of the three petals so it just protrudes into the flower.

3. Cup the three larger petals around the inner petals, overlapping and alternating them as you go. Making tiny stitches in a matching thread, sew these larger outer three petals to the stem in the middle until secure. Add a few blobs of glue underneath, too.

TO MAKE AND ADD THE CENTRE

1. Wet felt three tiny pieces of pollen as per the method on page 75, using bright yellow wool tops, leave to dry.

2. Use some fabric glue to stick the pollen pieces onto the very top of the stem coming up through the centre.

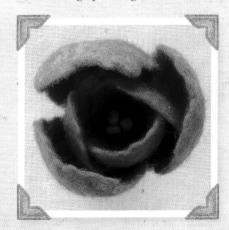

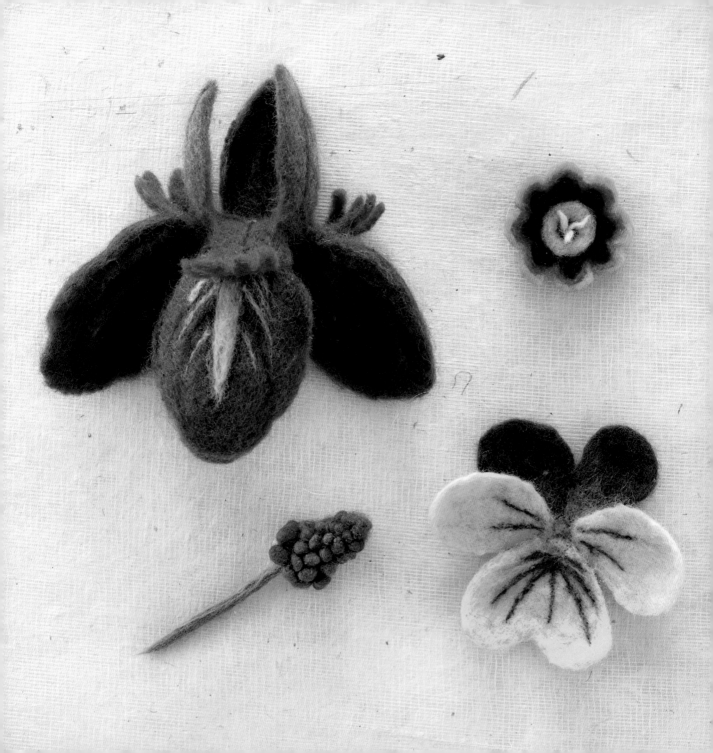

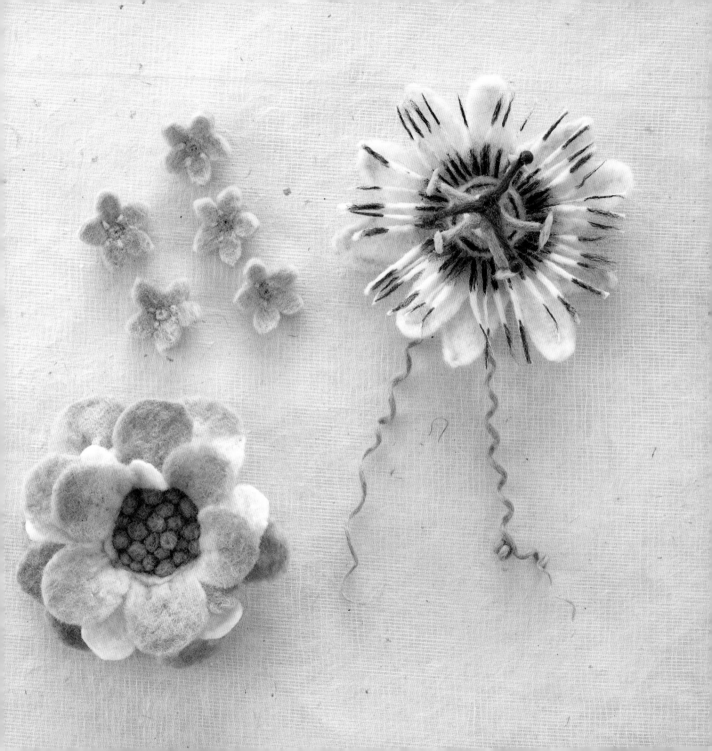

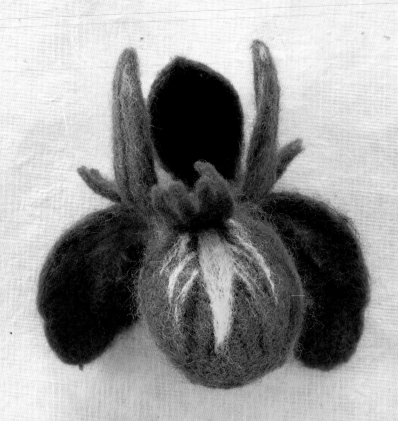

Iris
Iris latifolia

YOU WILL NEED

Merino wool tops

20g (⅔oz) delphinium bright
purple (or large square of
ready-made purple felt)
Small amounts of lilac, white,
navy, bright yellow and gold
for the markings

Other requirements

Wet felting essentials
Needle felting essentials
Foam

(Advanced)

Makes one iris

MAKING THE FELT FOR THE PETALS

1. Referring to the method on page 70, start by making a square of delphinium purple felt that measures at least 25cm (10in) square.

CUTTING AND SHAPING THE PETALS

1. Referring to the templates on page 79, cut one set of the large three petal shapes for the fall petals that hang down (1). Next cut one set of the three standard petals that stand up (2), and cut three of the smaller crest, frilly petals that sit on top of the fall petals (3).

2. Fall petals: referring to the method on page 68, needle felt a bright yellow beard onto each fall petal and add a deeper gold throat at the base of each one. Now add matching veins of white and navy on each petal. Keep these lines delicate and as fine as you can and try to make them roughly the same design on each of the petals.

3. Using the corner of the foam, start to needle into the back of each of these fall petals so they are slightly more cup-shaped. Also needle into the sides of each petal slightly, so that they look less uniform and bit more frilly. Keep needle felting these petals until they feel firm and well shaped. Each should be slightly domed in the middle.

4. Standard petals: add a very cobwebby amount of lilac wool tops over each and needle felt together to give them a slightly paler contrasting colour. Keep needling from both sides of each petal, and add some navy blue veining on the back of each.

5. As in Step 3, start to shape the petals so they curve and dome inwards (in the opposite direction to the fall petals) as these are going to cup together at the top of the flower.

6. Finally work on the three individual style crest petals. Each petal should have several cuts along the top to make it frilly or serrated looking. There is no further detailing to add.

PIECING TOGETHER

1. Lay a style crest petal onto each of the fall petals and attach them together at the base of each one using the felting needle. Attach the base only. As you stab into the base of each petal it will lift the frilly end up into the air slightly and help sculpt the shape. Persevere if it doesn't happen straight away! The bottom end of each petal should become completely embedded into each fall petal. You can needle on a little extra bright purple over the bases if you need to.

2. Now add the standard petals on top. Needle the centre down into place securely, again adding a little extra bright purple wool if you need to. Keep needling until firm and well attached.

3. Sit the iris on the corner of your foam, and needle into the underneath and side of each top standard petal until they start to sit up. The action of needling in from the top and then in from the side will eventually make the top petals sit and point upwards.

4. Finally, needle a small yellow centre and a few small navy veins into the very centre of the flower.

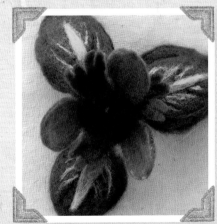

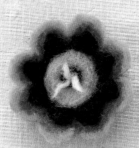

Auricula
Primula auricula

YOU WILL NEED

Merino wool tops

30g (1⅓oz) bright orange (or piece of orange shop-bought felt)
Small amounts of bright yellow, aubergine, red and white for petal markings and stamens

Other requirements

Wet felting essentials
Needle felting essentials
Small embroidery scissors
36 and 38-gauge felting needle

(Easy)

Makes a few auricula flowers

WET FELTING THE AURICULA FLOWERS

1. Referring to the method for wet felting a piece of flat felt on page 70, make a piece of bright orange felt to end up measuring about 20cm (8in) square. Alternatively you could use shop-bought felt, although the end result won't look quite as handmade. Also, handmade felt accepts the needle felting better and is slightly more sculptural to work with.

CUTTING AND SHAPING THE PETALS

1. Cut out a circle measuring approx. 4cm (1½in) in diameter for each auricula flower.
2. Using small embroidery scissors, cut a 5mm (¼in) snip into the circle at 12 o'clock, 3 o'clock, 6 o'clock and 9 o'clock to create four segments. Next, add a further snip in the centre of each segment to create a further four segments. You should now have eight segments.
3. Now use your small sharp scissors to carefully round off the corners of each segment, turning them into eight even petals.

ADDING THE DETAILS

1. To add the markings, use a 38-gauge star felting needle and small amounts of wool tops. Be very careful about where you place the wool and where you stab into the petals as auricula flowers are very neat and precise looking!

2. Start by adding the bright yellow centre. Referring to the technique for needle felting on page 67, start to add small amounts of bright yellow wool tops into the very centre of the flower, creating a neat and opaque circle about 1.5cm (⅔in) in diameter.
3. Referring to the picture opposite, start to add the petal decorations. Use aubergine wool tops to create a little scallop shape coming outwards into each petal above the yellow, then add a band of red wool tops around the top of the aubergine – but leaving some orange showing at the edge of each petal.
4. If necessary, keep needle felting more wool onto each colour until the colours look opaque and solid.
5. Now use a small amount of aubergine wool tops right in the very centre of the flower. Keep stabbing until the centre starts to indent. Use a sturdier 36-gauge needle to make this more pronounced if necessary.

MAKING AND ATTACHING THE STAMENS

1. Referring to the method on page 74 make three white stamens using white wool tops, each about 5cm (2in) long.
2. Thread the finished stamens, one by one, through the eye of a large needle, and carefully feed them up through the centre of the auricula. Secure each one underneath with a knot or a small blob of glue and trim so that they just protrude out from the centre of the flower.

Grape hyacinth
Muscari latifolium

YOU WILL NEED

Merino wool tops
20g (⅔oz) delphinium
Small amount of green
for the stem
Tiny amounts of purple
and white for details

Other requirements
Wet felting essentials
Needle felting essentials
38-gauge felting needle
Strong fabric glue

(Intermediate)
Makes a few grape hyacinths

WET FELTING THE HYACINTH BALLS

1. Start by making all the small delphinium-coloured balls which will be attached to the main flower. These should be loosely wet felted by rolling tiny amounts of wool between your fingers, one by one (see page 75). Be careful not to make them too dense and hard as you will be needle felting them onto the flower later.

2. Make 50 balls, about a third of them should measure approx. 5mm (¼in), a third of them 3–4mm (⅛in) and the remaining third about 2–3mm (⅙in). This is all very approximate, but you are aiming to have the balls gradually getting smaller as they go up the finished flower.

3. Once the balls are made, leave them to dry and prepare the base on which you will attach them.

PREPARING THE BASE

1. The base for this flower is needle felted using delphinium wool tops and a 38-gauge star profile felting needle. Take approx. 10cm (4in) of delphinium wool tops and coil it up tightly, folding in one side as you roll it up to make a cone shape. Start to needle this all around from each side. Once it starts to take shape you can add more wool, where necessary, to refine the shape. The aim is to end up with a small cone shape measuring approx. 3cm (1¼in) from top to bottom. Keep needling until it comes together and is relatively firm. You need to be patient!

ATTACHING THE BALLS TO THE BASE

1. Now start to attach the wet felted balls you made earlier, starting with the largest at the wide base of the cone. Using tiny amounts of purple wool tops to help secure them, needle around the edge of each ball until it is attached. Don't try stabbing through the middle of each ball as you want them to protrude and look round rather than squashed!

2. Adding the new purple wool tops around them should add depth and make the flower look more realistic. Work up the cone until the whole thing is covered with balls, with the smallest balls right at the top. Add further purple wool tops around them to make sure they are secure.

3. Now add tiny amounts of white wool tops at the base of some of the balls to give the flower a more realistic appearance.

MAKING AND ATTACHING THE STEM

1. Referring to the method for stems on page 73, make a stem to end up about 3–4mm (⅛in) wide and about 6cm (2½in) long. Once dry, trim one end and needle felt or glue to the base of the cone shape.

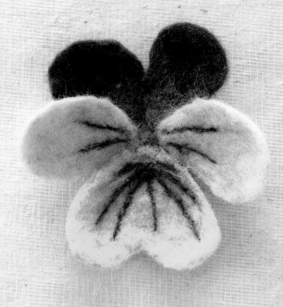

Pansy
Viola tricolor

YOU WILL NEED

Merino wool tops

20g (⅔oz) bright yellow
20g (⅔oz) purple
20g (⅔oz) pale yellow
Small amount of orange,
white and gold

Other requirements

Wet felting essentials
Needle felting essentials
Fabric stiffener
Strong fabric glue
36 and 38-gauge felting needle

(Intermediate)

Makes a few pansies

MAKING THE PETALS

1. Referring to the templates on page 80 and the technique on page 68, needle felt the shapes of the pansies. Use the bright yellow wool tops for the heart-shaped petal. Make two smaller petals in pale yellow (2) and two in purple (3).

2. Add a little white detail at the base of the two purple petals and, referring to the picture, add some purple veins and markings on the yellow petals.

3. Once the petals are well held together, wet felt them as per the method on page 72.

4. Coat each of the petals in a diluted fabric stiffener and push out with your thumbs to shape and cup slightly. Leave to dry.

PIECING TOGETHER

1. Arrange the five petals in the pansy shape, using the picture as reference. The two purple petals sit at the back, the pale yellow on either side, and the bright yellow heart upside down at the front.

2. Using a single 38-gauge felting needle, take a small amount of gold wool tops and needle felt all the petals together in the very centre where they overlap slightly (see page 69).

3. Add some orange wool tops underneath and some white wool tops above. Move to a larger 36-gauge needle to indent the centre of the flower a little more.

4. Finally, add a little more purple over the top of the original markings to make them more prominent.

5. Add a small blob of glue in the centre at the back to make sure the flower remains firmly held together.

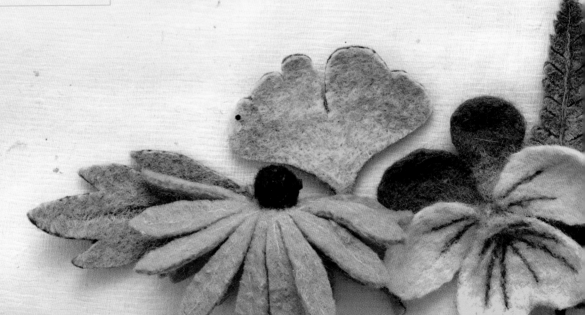

Forget-me-nots

Myosotis spp.

YOU WILL NEED

Merino wool tops

20g (⅔oz) lilac (or large square of lilac ready-made felt)
20g (⅔oz) pale blue
Small amounts of white, bright yellow and olive green

Other requirements

Wet felting essentials
Needle felting essentials
Small sharp scissors
36 and 38-gauge felting needles

(Easy)

Makes 9–10 forget-me-nots

MAKING THE PETALS

1. Referring to the wet felting method on page 70, start by making a rectangle of felt that measures at approx. 15 x 20cm (6 x 8in). You can use a sheet of ready-made felt instead, but the handmade felt will give you more depth of colour with a more realistic look and finish. It is also more accepting of the new needle felted wool tops which get needled on top.
2. When laying out the wool tops for the hand-felted piece, use lilac wool tops in one direction with pale blue wool tops over the top in the opposite direction. Leave to dry.
3. Referring to the template on page 76, cut as many flower shapes as you'd like to make using a variation of the two different colours from either side of the piece of felt you've made. Use small sharp scissors and cut the small shapes as neatly as you can.

NEEDLE FELTING THE CENTRES

1. Referring to the needle felting method on page 68, use a single 38-gauge felting needle to add tiny amounts of bright yellow wool tops in the centre of each flower.
2. Add equally small amounts of white wool tops around the yellow centre, as small white markings radiating outwards. Use the picture as reference.
3. Finally, use the larger 36-gauge felting needle to indent the very centre of each bloom slightly. This will make them look more realistic.

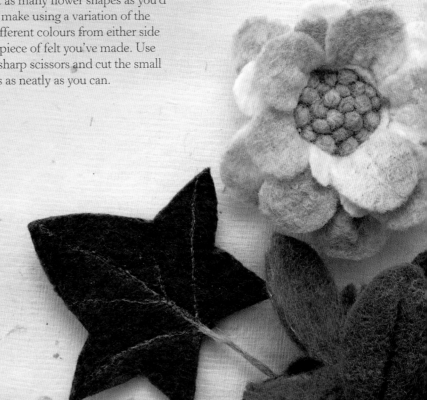

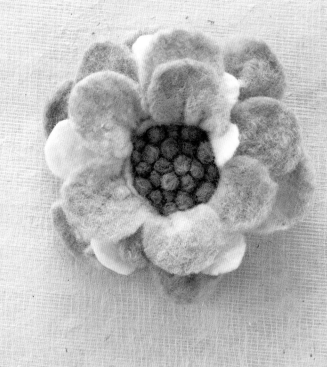

Scabiosa
Scabiosa caucasica

YOU WILL NEED

Merino wool tops
25g (1oz) lilac
25g (1oz) white
Small amounts of white, lilac,
dusty pink, sage green, dusty
mauve, peppermint green, salmon
pink and olive green

Other requirements
Wet felting essentials
Needle felting essentials
Felting needle

(Intermediate)
Makes one scabiosa

MAKING THE FELT
1. Using the long lengths of both the lilac and the white wool tops, lay out fine amounts of lilac wool in a line about 60cm (24in) wide with the wispy ends pointing downwards. Add to this line underneath using the white wool, allowing the wispy ends to overlap and point upwards. When it's finished, the felt should be fine and cobwebby so it will be easier to manipulate into the flower petals.
2. Referring to the method on page 70, felt the wool together to form a long piece that will shrink by 20 per cent to about 40cm (16in) wide.

CUTTING AND SHAPING THE PETALS
1. Using the template on page 78 as a guide, cut six large flower petals (1) and 8–10 smaller flower petals (2) from the length of felt. Each petal should fade from lilac to white.
2. Referring to the method on page 68, use a felting needle to gather together each cut petal at its base. This will cause the sides of the petal to crease a little – just like a real flower. Do this to all of the petals.

ASSEMBLING THE FLOWER
1. On some foam, lay a small amount of white wool tops into a circle about 2.5cm (1in) wide. Lay the six larger cut petals out evenly on top, overlapping them slightly in the centre.
2. Use the felting needle to attach together all the larger petals in the middle, then add six of the smaller petals to the centre of the flower in between the larger petals.
3. Needle them together too and keep adding more new white wool tops into the very middle of the flower to build up the centre. It pays to add a little more white wool to the back of the flower centre too, to help everything attach firmly together.
4. As you keep needling, the centre will get bigger and firmer and the petals will start to take shape and stick upwards and outwards. Sculpt them into position by needling them at the base of each.
5. When all the petals are firmly attached to a white centre, use some sage green wool tops to build the centre up further into more of a domed shape.
6. Needle on some small offcuts of the white and lilac felt around the base of the domed centre. This will make the flower look more realistic.

ADDING THE DETAILS
1. Keep needling the centre until it is very firm and all the petals feel well attached. There should be a couple of extra petals which you may want to add into any gaps that have appeared. If so, attach them right at the base of each and stab firmly into position with the needle.
2. Create tiny balls of sage and olive green wool by compacting them between your fingers before needling them onto the centre of the flower. Needle them only around the very edges, so that they protrude in the centre, and add texture to the centre of the flower. Butt them up closely to one another and fill the whole of the centre with them.
3. Needle on very fine wisps of all the other colours in and around the tiny balls, as this will create a more natural and interesting look.
4. If necessary, use a matching thread to add a few small stitches at the back of the flower to keep petals in position. As you pull the thread tight at the back, you will be able to sculpt the petals further and create a more natural looking shape.

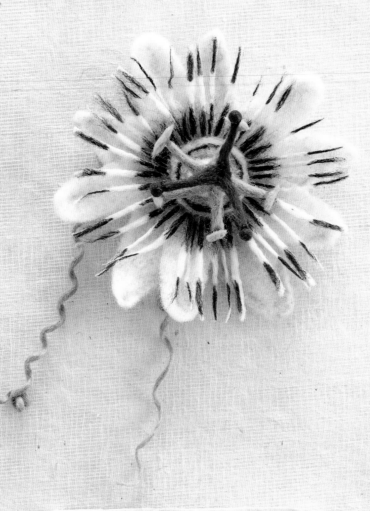

Passion flower
Passiflora caerula

YOU WILL NEED

Merino wool tops
30g (1⅓oz) white
20g (⅔oz) sage green
20g (⅔oz) citrus green
15g (½oz) maroon
Small amount of aubergine

Other requirements
Wet felting essentials
Needle felting essentials
38-gauge felting needle
Fabric stiffener
Strong fabric glue
Light purple and dark purple
waterproof marker pens
Paper
Foam
Pins

(Advanced)
Makes one passion flower

MAKING THE PETALS

1. Referring to the wet felting method on page 70, make a piece of white felt measuring approx. 20 x 30cm (8 x 12in). Use the templates on page 78 to cut two shapes for the two different sets of passion flower petals.

2. Using a single 38-gauge felting needle, add a little detail to the outer edges of these petals using fine small wispy amounts of sage green wool. Don't use too much – it should be subtle detailing!

MAKING THE STAMENS

1. Referring to the method on page 74 and using white wool, make about 40 narrow stamens, each about 4cm (1½in) long. Either make them separately or, better still, make a few really long ones and then cut them up. Leave to dry and cut accordingly until they are all roughly the same length.

2. Place them around the flower – each one radiating outwards from the centre. Keep them as evenly spaced as you can. Stick them securely in place with a large blob of glue in the centre of the flower. Leave to dry.

3. Place a sheet of protective paper underneath the stamens before you use the marker pens. This will protect your lower petals and keep them free of ink.

4. Use the lighter of the two purple marker pens to colour the top 1cm (½in) of each stamen. Move the paper around underneath them as you work around the circle.

5. Leave 1cm (½in) clear white in the centre and use the dark purple marker pen to colour the base of each stamen. Leave to dry.

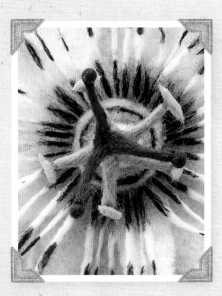

MAKING AND ASSEMBLING THE REST OF THE FLOWER

1. Make a disc of green felt, about 2.5cm (1in) in diameter, using citrus green wool tops. You can use an offcut from another piece or needle felt a new piece – it doesn't matter.

2. Use a single 38-gauge needle to add a fine aubergine line around the inside of this green disc. Stick the disc into the centre of the flower on top of the stamens.

3. Wet felt a small white ball (see method page 75) about 1.5cm (⅔in) in diameter. Cut the ball in two and needle an aubergine disc into the middle of it. Stick this on top of the green disc.

4. Make a thick sage green stamen about 2cm (¾in) long and about 5mm (¼in) wide (see method page 74).

5. Make a five-armed sage green star-shaped stamen (see photo page 59) by needle felting together five 2cm (¾in) pieces of sage green wool tops. Needle felt them (see method page 69) until well held together, especially in the middle. Now wet felt this star-shaped stamen to really mould it and get it to felt down further. Rinse and leave to dry.

6. Repeat the above procedure with maroon wool tops and make a three-armed stamen. Again, leave to dry.

7. Make five citrus green elongated pollen and three maroon 5mm (¼in) pollen (see method page 75).

8. When all the component parts are dry, glue a piece of green pollen onto each branch of the five-armed stamen and a piece of maroon pollen onto each branch of the three-armed maroon stamen. Leave to dry.

FINAL ASSEMBLY

1. Working on a piece of foam, use a combination of strong fabric glue, sewing pins and felting needles to hold things in position as you construct the rest of the flower. Leave each layer to dry before adding the next. It's a bit like building up a wedding cake in layers!

2. Take the 2cm (¾in) single sage green stamen and cut in two. Glue the first half onto the white ball in the middle of the aubergine circle and leave to dry.

3. Attach the five-armed green stamen with a blob of glue underneath. Leave to dry.

4. Add the second half of the single green stamen. Leave to dry

5. Add the maroon three-armed stamen. Leave to dry

TENDRILS

1. To make tendrils, make a very long sage green narrow stamen (see method page 74). When it's finished, coat with a fabric stiffening solution and coil around a thick rod or skewer – even a pencil or pen would do.

2. Leave to dry and then remove the rod or skewer. You will be left with a lovely passion flower tendril.

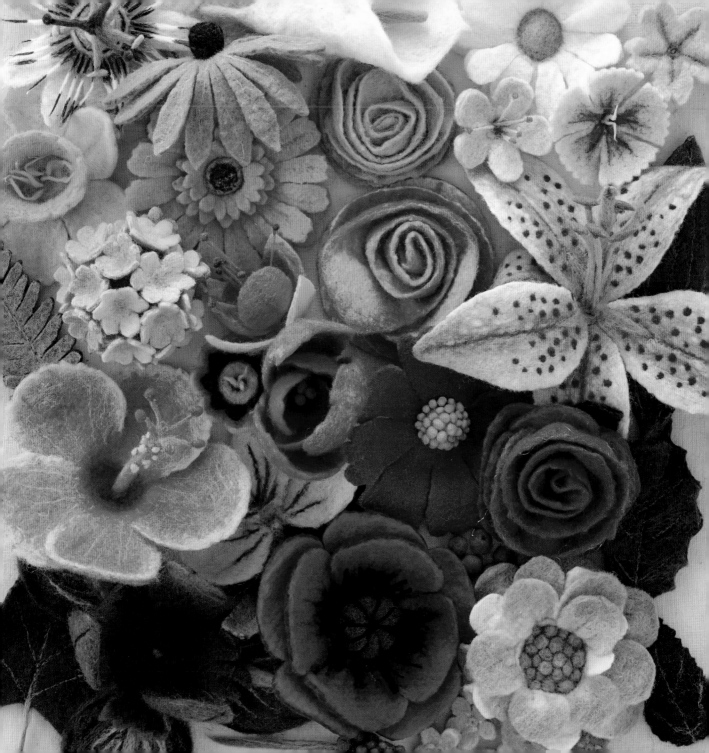

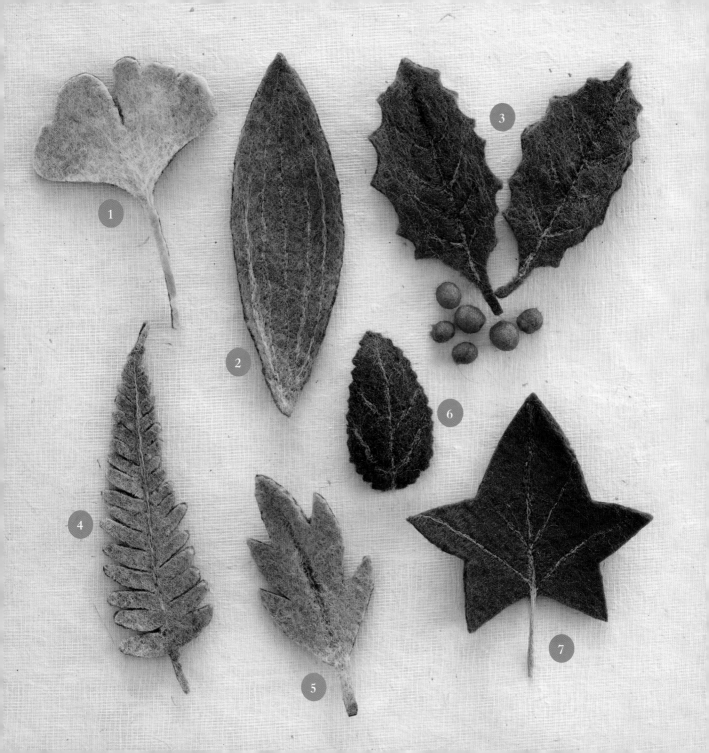

Leaf shapes

Making leaves to complement your finished felt flowers adds the prefect finishing touch. Sometimes just a 'generic' leaf shape is all that's needed, and you can choose a colour to suit, but here are a few examples of specific leaves to make in felt.

YOU WILL NEED

1 x 20cm (8in) square of felt in relevant colour/s, made referring to method for wet felting on page 70. Material details are give below for each leaf. It is also possible to use a shop-bought felt, although handmade felt will give you a more interesting and realistic finish, and you can tailor the leaves to your own colour palette.

MAKING THE FELT

1. Use the relevant template (see pages 76 to 79) for the leaf you are making and pin to your finished piece of felt.
2. Use small sharp scissors to carefully cut around the template and cut as many leaves as required
3. Referring to the needle-felting method on page 68, add appropriate veining and detailing for each leaf.
4. If necessary, shape or harden by re-wetting the leaves and soaking in some fabric stiffener. Squeeze out excess and shape to dry – it's a great way of adding a bit of leaf curl!

1. Gingko leaf
20g (⅔oz) emerald green
20g (⅔oz) citrus green for top layer of wool tops
Pinch bright yellow for needle felting detail above stalk

2. Lily leaf
20g (⅔oz) British racing green
20g (⅔oz) emerald
Pinch citrus green for veining

3. Holly leaves and berries
30g (1⅓oz) British racing green
Pinch grass green for shading
Pinch lime green for veining
20g (⅔oz) bright red for berries
10g (⅓oz) cherry red for detailing

Make several berries according to 'Wet felting balls, berries and flower centres', page 75. Add needle felting detail to the ends of each berry with the darker red wool, using just one felting needle.

4. Fern leaf
20g (⅔oz) British racing green for back layer
20g (⅔oz) mid-olive green for upper layer
Pinch soft yellow and sepia for veining

5. Poppy leaf
20g (⅔oz) British racing green for back layer
20g (⅔oz) sage green for upper layer
Pinch grass green for veining

6. Rose leaf
20g (⅔oz) British racing green for back layer
20g (⅔oz) dark olive green for upper layer
Pinch sage green for veining

7. Ivy leaf
30g (1⅓oz) British racing green for both layers
Pinch sage green and olive green for veining

8. Passion flower leaf
20g (⅔oz) British racing green for back layer
20g (⅔oz) dark olive green for upper layer

8

Wool tops

What are wool tops?
A wool top is wool that has been taken from a sheep's fleece, and has been cleaned (scoured) and combed (carded) so that all the fibres face the same way. It is wound into a continuous length and sold by weight. It is perfect for felting as the fibres are easily pulled from one end of the length. (Wool roving is very similar to wool top, but the fibres do not always face the same way.)

Merino wool tops
Merino wool is most commonly used – particularly for wet felting. Merino sheep like a warm climate and produce very fine wool with a fine crimp. This wool therefore felts the fastest and is often the one dyed into the many inspiring colours that we use for felting. This in turn then lends itself perfectly to felt flower making, as obviously colour is key! All the wool used in this book is Merino Wool.

Other sorts of wool tops
Any wool will felt eventually, but if you are interested in experimenting with other wools, it is worth bearing in mind that some wool will require a great deal more rubbing and working when it is wet felted. Different sheep breeds are all graded differently according to fibre length and thickness. Some are much rougher and thicker and produce different results – not all of which would be suitable for making felt flowers. Having said that, some people find needle felting easier with some rougher wools, so it is worth having a go if you are interested. But remember to choose a wool that you can get hold of in the colours that you want!

Storing wool tops
Always store your wool away from extremes of temperature and, most importantly, away from moisture. Too much moisture – even from the air – makes wool start to felt and it will become matted, which makes it harder to work with. Store the wool tops in plastic bags, and take care to repel moths.

Storing partly finished projects
If you are unable to finish a wet felt project in one sitting, it's fine to leave it in an OPEN plastic bag and go back to it another day. However, do not seal the bag as the wet felt will go mouldy and start to smell. It is fine to re-wet the fibres if the felt has dried out.

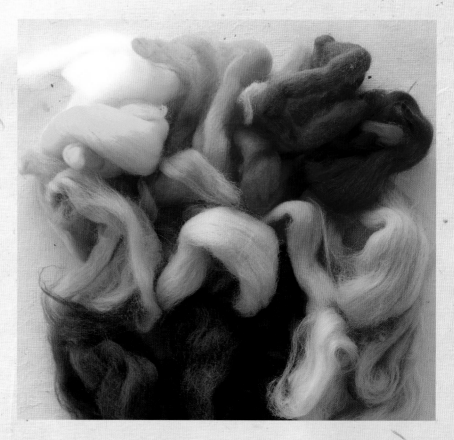

Equipment and materials

Workspace

Wet Felting: Work on a reasonably large table near to a sink and tap if you are wet felting. Protect your work surface when wet felting as it will become wet and soapy. You should expect a few soapy splashes.

Needle felting is more self contained, so is suited to any workspace, table or desk. The most important thing is to work onto a piece of foam, to provide support under your work and protect your worktop.

Wet felting essentials

Netting

You'll need a piece of medium weight polyester netting to lay over your wool fibres before wetting them for wet felting. The net lets you rub the fibres together with minimal disturbance.

Soapy water solution

Make a mixture of lukewarm water with a dash of washing-up liquid. You will need some sort of spray bottle or squeezy bottle to dispense it from.

Bar of soap

Any soap will do! The alkalinity of the soap is what's important here as it speeds up the felting process and its slipperiness aids rubbing.

Dish cloth and jug

To eliminate the risk of over-wetting your fibres, use a dishcloth to mop up excess water and spread retained water through the wool fibres. Keep a jug or bowl handy to squeeze the dishcloth into.

Bamboo mat

Once the first stage of the felting process is complete and the fibres have been rubbed together, the fulling stage begins. Using a bamboo mat is the best option for achieving fast effective 'fulled' results. (Bubble wrap can be substituted if necessary but is less effective.) Remember to make sure that your bamboo mat is large enough to fit your project onto.

Old towel or tea towel

These are great for general mopping up and also for laying under the bamboo mat to keep it in place during the rolling process. It is important that you dry your hands in between touching wet felt and dry wool, so keep a dry towel close by.

Needle felting essentials

Protective foam

Use a rectangle of dense foam under all your needle felting. This will protect your table and it will also protect you if you are not working at a table!

Felting needles

You will need a selection of the two different sizes of felting needles used in the book – a selection of 36-gauge triangular profile needles and 38-gauge star profile needles would be ideal. Felting needles have small barbs at one end, which catch and entangle the fibres as you stab them in and out. The larger needles are better suited to more sculptural work or felting that seems harder to achieve. The 38-gauge needle is a good all rounder and can be used for general work and for decorative work too.

These needles will snap if not used correctly*. It is really vital that you aren't too heavy-handed with them. They should be used GENTLY and kept fairly upright and not bent over or used at an angle. Then they will last for ages.

*Felting needles are extremely sharp, so use them with caution and take great care.

Multi-needle tool

An indispensible tool for needle felting larger areas more quickly. Highly recommended for needle felting larger flat petals in particular.

Needle felting

Needle felting whole petals

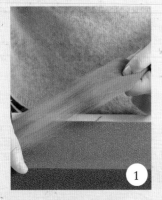 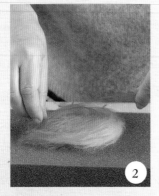 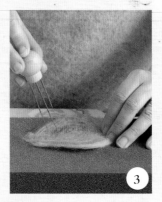 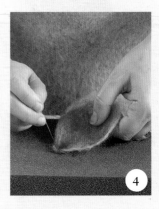

1. Pulling off fibres

To needle felt a whole petal, start by pulling off really wispy amounts of wool. Hold the wool top length about 15cm (6in) from the end with your left hand (if right-handed). Use your writing hand to pull the very ends of the fibres away. The wool should come away easily and be fairly fine and wispy. If the wool is too difficult to pull away, you may be grabbing too much at once, or your hands may be too close together. You don't need huge amounts for making petals, so sometimes you may need only half of the width of the wool, or maybe even just a few fibres.

2. Laying out fibres

Lay the fibres directly onto a piece of foam, or similar material, to protect your workspace and provide support for your needle felting. Shape the wool fibres into the shape of your petal, remembering to make it slightly bigger than required, as it will shrink down when felted with the needles. Layer small amounts of different colours over one another to provide subtle shading and depth. Once a petal is needle felted it will look more interesting if several different shades have been used together.

3. Needle felting flat pieces

Use felting needles with care. They are extremely sharp and it is painful if you stab your finger rather than the wool, so keep your fingers well away from the needles. Using a multi-needle tool will speed up your needle felting, but it's also possible to just use one or two needles in your hand. Keep the felting needle or multi-needle tool perpendicular to your work, and always stab the needles in and out of the wool GENTLY to avoid needle breakage. Keep turning your petal frequently, or else it will adhere to the foam.

4. Refining

As you continue to stab the needles in and out, the petal will start to felt more, will become less fluffy, and will stop sticking to the foam as much. The more you continue to felt, the more refined it will become. Keep refining your petal with the felting needles until it feels matted and smooth, then use a single needle to add fine details to it if required. It is possible to keep adding wool with either the single needle or a multi-needle tool until you are happy with it!

Needle felting balls and flower centres

About felting needles
Felting needles come in different shapes and sizes, but you don't need many different sorts. It's good to have a larger 36-gauge (I use a triangular profile) needle for more sculptural work that requires greater effect. The general 38-gauge (I use a star-shaped profile) is a great 'all rounder' and will sculpt and also embellish with ease. A combination of these two – or some that aren't too far off – is normally sufficient. Experiment with the two sizes – most work is done with the 38-gauge needle, but sometimes you will resort to the larger 36 needle and it will seem to work faster. Often it's just personal preference!

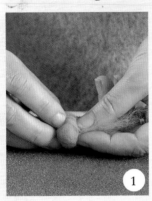

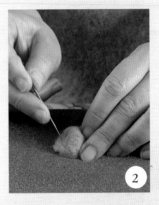

1. Coiling up wool
Gather some wool tops together and roll them up into a REALLY TIGHT ball, making sure that a fairly wispy piece of wool coats the outside to avoid channels forming. Coil the ball slightly larger than you want it to end up, as it will reduce in size as it felts and the air inside the fibres is removed.

2. Needle felting balls
Hold the ball with one hand taking care to keep your fingers out of the way of the felting needles. Start to felt the ball with one needle – stabbing very GENTLY and keeping the needle perpendicular to your work. Mind your fingers! Rotate the ball as you go so that you felt around it evenly. Gradually it will start to feel more solid and held together. Keep the ball or flower centre in the shape you want it by remembering that repeated stabbing in one area will result in that part reducing inwards.

3. Finishing
As you continue to needle felt the ball, it will become more refined and less fluffy. The air inside the fibres will be removed and the ball will seem smaller and firmer. Shape the ball further by indenting certain parts with repeated stabbing in the same place. However, if you don't want this to happen, make sure that you continue to rotate the ball.

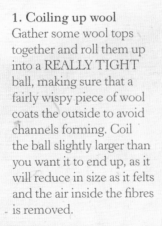

Needle felting details

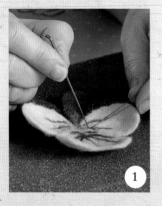

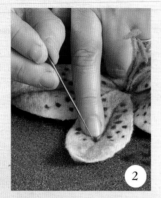

Needle felting to shape

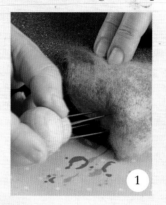

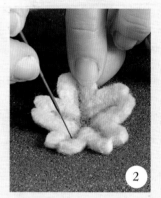

1. Veins and lines

A good way of adding detail to your flowers and their petals is to use a single felting needle with very small amounts of wispy fibres. The single needle allows you to be very precise and get lines and shapes exactly where you want them. For veins and small lines use tiny lengths of wispy wool tops and allow the needle to guide the wool into the felt to add your details. Whilst you don't want the wool to lift off, the more you stab the needle into the wool, the more it will disappear into the petal, so find a happy medium. Always use the needle gently and make sure the

barbs are travelling all the way through the felt. Occasionally lift your work from the foam to prevent it attaching.

2. Spots and marks

To add spots or markings to petals, take tiny amounts of wool tops and coil or shape before needling into place. Use the needle gently and keep felting until each one is firmly attached. Using too much wool will result in the spots standing proud from the base fabric, so keep the wool used to a minimum. As the wool disappears into the felt add more if necessary. Lift your work occasionally from the foam to prevent it attaching.

1. Shaping petals/leaves

Shaping or 'rounding' petals can make them seem more realistic and felting around the corner of the foam can help achieve this outcome. Using the multi-needle tool, place the petal over the corner of the foam and start to stab in and out gently, taking care to keep your fingers out of the way! Push and pull the petal with your fingers too to help get the desired shape. The felt is often quite malleable and there's usually some give in it, unless very well felted. It's also effective to wet the petal again and stretch and shape. Leave to dry over a small ball or in a cup.

2. Indenting

Use a single (larger if you have one) needle to add indentations into a flower petal or ball. By repeatedly stabbing into the same area, you can achieve indentations and different shapes or deeper veining.

Needle felting to join shapes

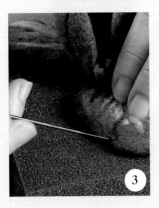

Top Tip
Always take care when needle felting – the needles are extremely sharp and are barbed at the end. If needle felting something very small, prevent injuries by holding the small piece you are working on with another needle instead of your fingers!

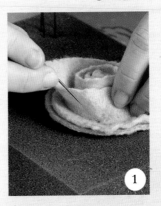

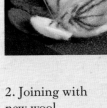

3. Shaping edges
Stabbing the felting needle sideways into the petal edges is a good way of getting a more realistic 'frilly' edge. Depending on the flower it needn't be too uniform. Use one larger 36-gauge needle for greatest effect and stab gently into the side of the petal – taking great care to avoid your fingers. Keep stabbing in the same place to create the indentation.

1. Joining
Different pieces of handmade felt (or shop-bought felt) can be joined just by needle felting them together. Always use the needle gently and don't bend it at an angle as you stab in and out. Keep needling into the same point a few times and then move along. Using the felting needle at the base of a coil or cut shape will help the petals protrude backwards and outwards and will help sculpt your flower to make it look more realistic.

2. Joining with new wool
Needle felting is a useful and clever way to join to felted elements together. Ideally they will still be a little fluffy – but if you find them difficult to join, adding some new wool tops onto the area will help. Just choose a colour used already in the flower. Adding fresh wool tops will make the shapes much easier to join. Always lift and move your flowers around the foam to make sure they don't get attached.

Wet felting

Wet felting flat pieces

1

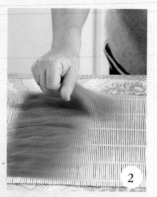
2

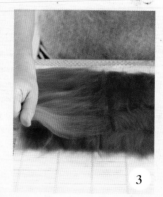
3

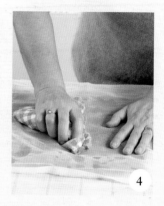
4

1. Pulling off the fibres
Hold the wool top length about 15cm (6in) from the end. Use your writing hand to gently release the very ends of the fibres. The wool should come away easily and be fairly fine and wispy. Try and pull off the full width of the wool in one go. If the wool is difficult to pull away you may be grabbing too much at once, or your hands may be too close together. For a finished piece of felt that isn't too thick, it's important to pull off fine, even amounts of wool rather than clumps, so do practise to get the technique right. On average felt shrinks by about 15–20 per cent once

finished, so start with the fibres laid out 20 per cent larger than you want the finished felt to be.

2. Laying out fibres
Lay the wool overlapping slightly, building it up gradually to create a fine even layer. Use sufficient wool so you can no longer see through it to the surface beneath – it should appear to be a solid colour. At this stage the layer is mostly air and once the wool has been wet down it will be much flatter.

3. Laying a second layer
When making most flowers you will need to make the felt two 'layers' thick. The next layer of

opposite direction to the previous one to achieve more even shrinkage and to make the finished felt more robust. Sometimes you may want to make these two different layers slightly different colours to make your flowers look more realistic.

4. Wetting down
Carefully lay netting over the fibres. Use a squeezy or spray bottle to sprinkle your soapy water solution (see 'Equipment and materials', page 65) over the netting. Hold the netting in place with one hand while use the other hand to spread the soapy water through using a dishcloth. It is

important that every fibre is completely wet and soapy, and that all the air is removed. It should feel as if the wool is stuck to the table with soapy glue. If it still feels springy to the touch, more soapy water is required. If it feels puddly and over wet, mop up a little. There is a fine line between too little and too much liquid – the fibres need to be wet through thoroughly, but if they are swimming in water it will prevent the felting from taking place as quickly.

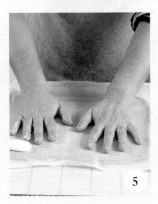

5

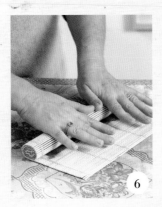

6

7

Top Tip

The rolling part of the felting process is called 'fulling' which further shrinks and hardens the felt. The bamboo mat provides good friction as it pushes back and forth against the slats. There are other ways of doing this, but the bamboo mat method is the fastest and most effective. Place an old towel under the mat to prevent it from sliding around.

5. Soaping/rubbing

Rub a bar of soap across the the netting to make it slippery. The soap is a vital part of the felting process and encourages the felting to happen faster. Keeping the netting flat and taut, rub with both hands and plenty of pressure for approx. 10 minutes. (Some fibres may cling to the net as you rub. If they do then carefully peel the net back, remove the fibres and replace the net in a different position.) After 10 minutes, remove the net, turn the felt over, replace the net and rub for a further 10 minutes on the other side.

6. Rinsing/rolling

Rinse the felt gently under lukewarm water. Do not immerse in water – simply 'show' it the water under the tap, then wring gently. Repeat until most of the soap has been removed, then squeeze out excess water. Roll the felt up tightly in a bamboo mat. It will start to shrink in the direction it is rolled in, so to achieve an even shrinkage it is necessary to keep rotating the felt as you roll. Roll the mat back and forth with a firm even pressure about 20 times. Unroll, turn the felt 90° clockwise and then repeat. Continue through 360°, then turn the felt over and repeat on the other side

too. Now rinse in hotter water and remove all the soap, wring, then repeat the whole rolling process again.

7. Finishing/cutting

The finished piece of felt will have shrunk quite significantly and should have a final roll (in any direction) to flatten and finish. Leave to dry. Pin a template to the felt and cut out shapes from it with some sharp scissors. The felt will not fray, but the more 'felted' it is, the less fluffy the edges will become over time.

Wet felting separate petals

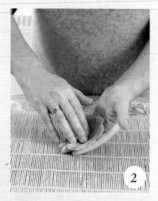

1. Laying out wool into specific shapes

Sometimes you may want to lay out the wool tops into a specific shape for each petal and wet felt them all individually. This will result in more realistic petals as their edges will be felted and more uneven. Due to the nature and size of the wool top fibres, it is better to do this for larger petals, bearing in mind that they'll shrink down. (Smaller flower petals are best cut from larger pieces.) Lay out the petals on a bamboo mat or waterproof surface. Follow the steps for wet felting, making sure each petal is about two layers thick.

2. Wet felting needle-felted petals

Sometimes it works well to needle felt a petal together first, then wet felt it afterwards to achieve more dramatic shrinkage and give a different look when finished. Simply wet and soap the petals and rub them for a few minutes on each side. Then proceed with the rinsing and the rolling steps for wet felting. Take care to remove all the soap at the end. Whilst they are still wet they are very malleable and can be shaped using a little fabric stiffener if required. Leave to dry 'cupped' or over the back of a small ball.

Wet felting stems

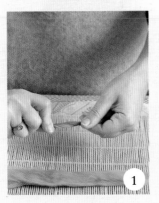

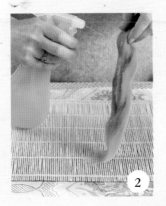

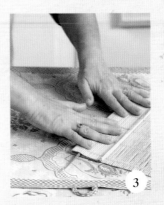

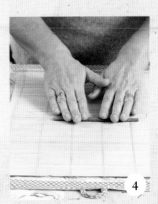

1. Checking the size
When wet felting stems, pull off the amount of wool you require and then 'twist' the wool to remove the air and help you work out how wide the stem will be once felted. Check this and adjust accordingly. Remember the stem will shrink in length a bit once wet felted.

2. Wetting/soaping
Wet each strand one at a time, using your soapy water solution in a spray bottle (see page 65), until thoroughly wet through to the core. Wring the stem slightly to remove excess water. Make your hands very soapy and soap the stem well.

3. Rolling
Place onto the bamboo mat and flip the end over the top of the stem. Roll back and forth with plenty of pressure. If the stem is very long, work up and down the length to cover all areas. As the stem starts to felt and harden, keep soap levels up and keep rolling. Rinse with hot water, re-soap and continue to roll for about 15 minutes or until hard and well felted.

4. Finishing/stiffening
Once the stem has felted, remove all the soap under the tap, and then roll it out again to finish on a soap free mat. To achieve more rigidity, it is possible to immerse the stem in some fabric stiffener. Once it dries it will be straighter and harder.

Wet felting stamens

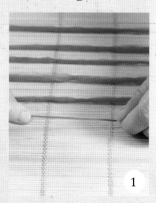

1

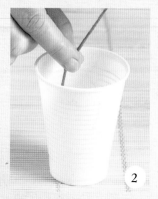

2

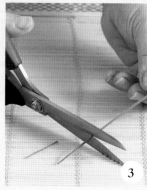

3

Top Tip

If you want to make several stems, berries or pieces of pollen all the same size it's sensible to prepare all your wool before you start to felt each one. By pulling off similar amounts for each one you'll know they will end up the same size when they are finished!

1. Checking the size
When wet felting finer stamens, pull off small amounts of wool from the length of the wool tops. Check the amount of wool you require by 'twisting' it to remove the air. This will help you work out how wide the stamen will be once felted. Check this and adjust accordingly. Remember the stamens will shrink in length a bit once wet felted. Follow the same process for wetting/ soaping and rolling as per stems (see page 72).

2. Stiffening
When stamens are finished they will often benefit from some fabric stiffener which will make them look more realistic. Pour a little into a plastic beaker and dip each stamen into the solution. Pull the stamen between your thumb and finger to remove excess fabric stiffener, then lay out on a tray to dry.

3. Cutting
Once dry, the stamens can be cut to length using sharp scissors before you add them to the flower. Once dry and stiffened, they will be easier to work with and easier to glue.

Wet felting pollen

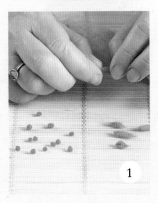

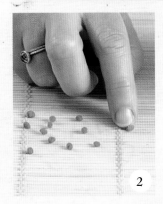

Wet felting balls, berries and flower centres

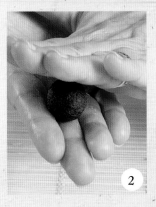

1. Coiling wool/sizing

To make pollen you will hardly need any wool at all. You'll find that the tiniest amount coiled between your fingers will usually suffice! To make elongated pieces of pollen just roll a ball and then flatten it out between your fingers. It's sensible to prepare similar amounts of wool for all your pieces of pollen before you start.

2. Felting/rolling

It's quite fiddly felting little pieces of pollen, but also quite quick. All you need to do is wet and soap each piece, then roll it around on the bamboo mat or in your palms for a few minutes. Then rinse and remove all the soap. They will also benefit from a little fabric stiffener before you leave them to dry.

1. Sizing/coiling

Gather some wool tops together and roll them up into a REALLY TIGHT ball, making sure that a wispy piece of wool coats the outside to avoid channels forming. Coil the ball slightly larger than you want it to end up, as it will reduce in size as it felts and the air inside the fibres is removed.

2. Soaping/rolling

Spray with soapy water solution until wet through to the core. Squeeze to remove excess water then soap the ball and your hands further using a bar of soap. Roll the ball very lightly between your palms, using very little pressure. After a few minutes it will start to harden and you can move on to rolling it with more pressure directly on the bamboo mat. When firm, rinse thoroughly in hot water until all the soap is removed. Leave to dry.

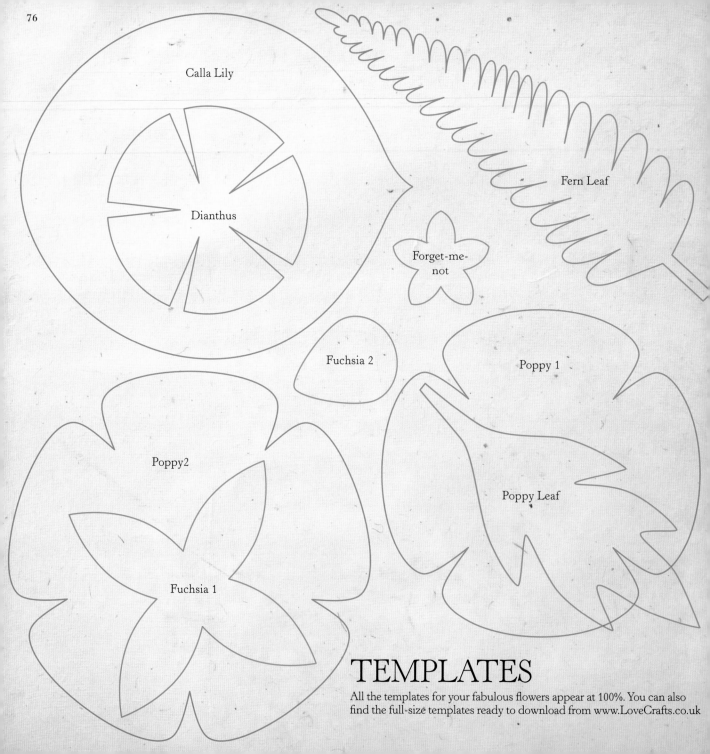

Calla Lily

Dianthus

Fern Leaf

Forget-me-not

Fuchsia 2

Poppy 1

Poppy2

Poppy Leaf

Fuchsia 1

TEMPLATES

All the templates for your fabulous flowers appear at 100%. You can also find the full-size templates ready to download from www.LoveCrafts.co.uk

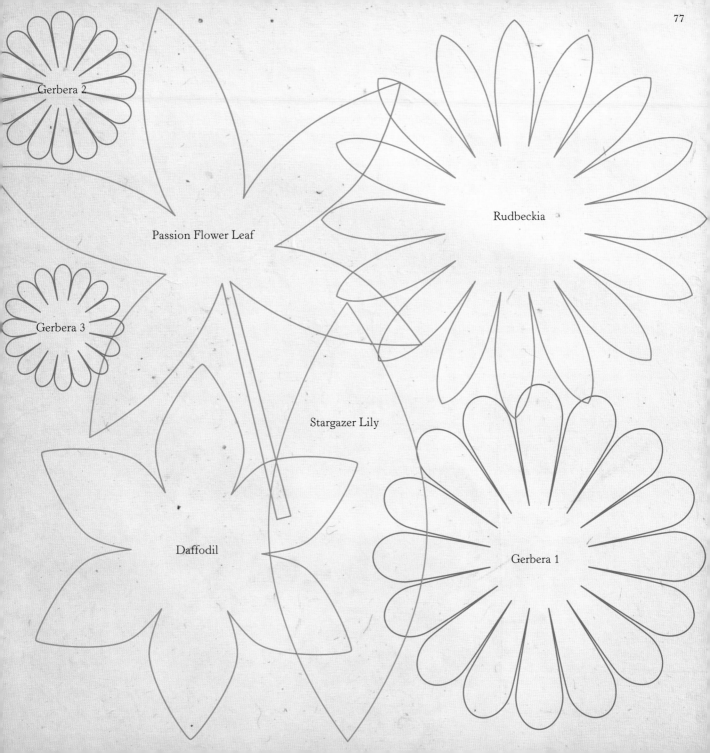

Gerbera 2

Passion Flower Leaf

Rudbeckia

Gerbera 3

Stargazer Lily

Daffodil

Gerbera 1

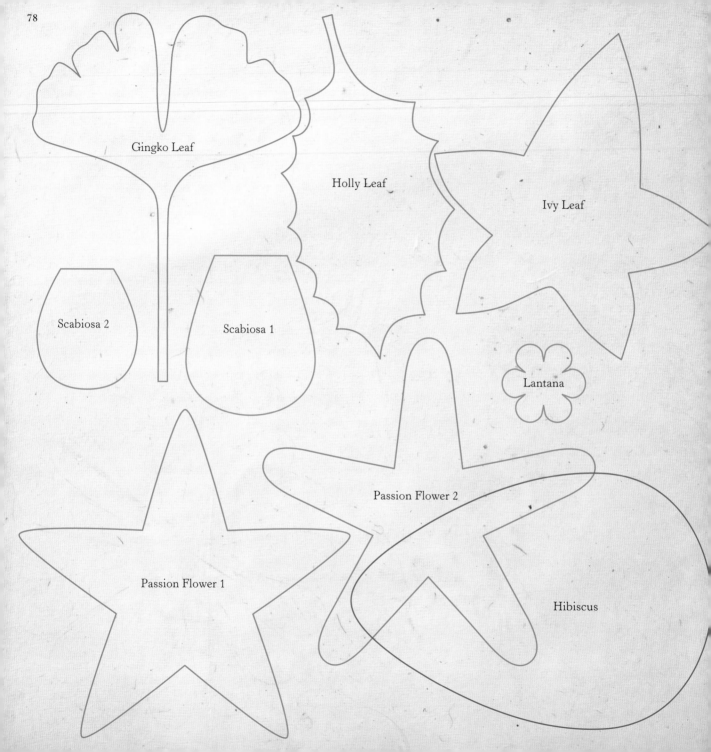

Gingko Leaf

Holly Leaf

Ivy Leaf

Scabiosa 2

Scabiosa 1

Lantana

Passion Flower 2

Passion Flower 1

Hibiscus

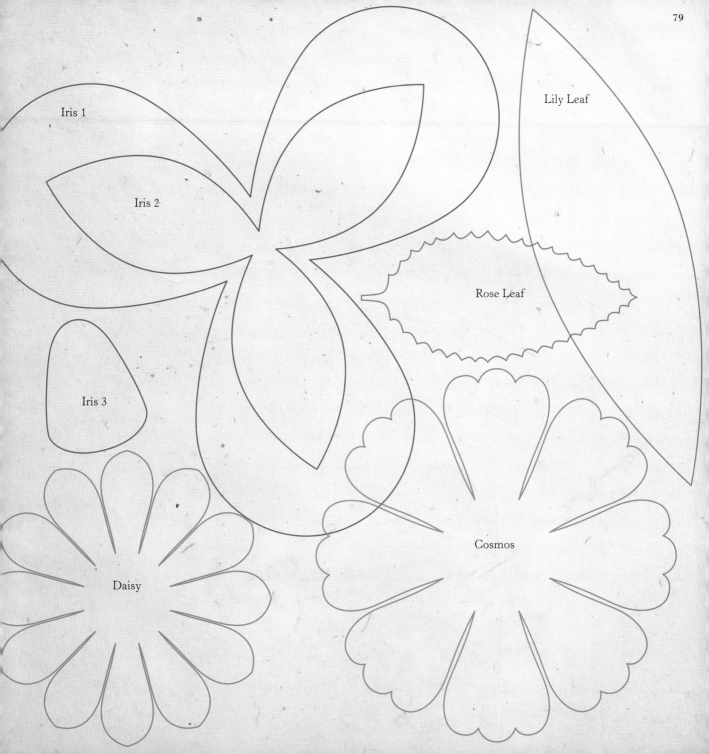

Iris 1

Iris 2

Lily Leaf

Iris 3

Rose Leaf

Daisy

Cosmos

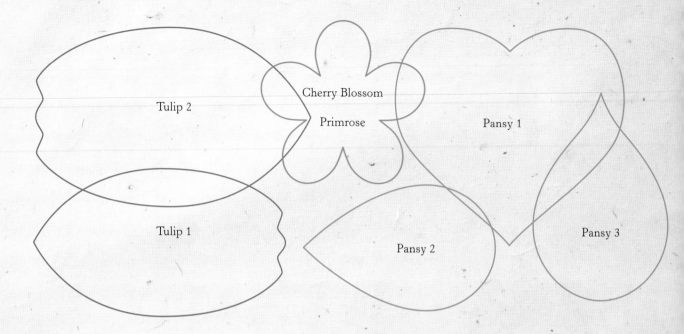

Tulip 2

Cherry Blossom

Primrose

Pansy 1

Tulip 1

Pansy 2

Pansy 3

Resources

For wool tops, wool blends, fibres, trimmings, wet felting and needle felting equipment, felting needles, fabric glue, fabric stiffener, kits, courses and more:

The Gilliangladrag Fluff-a-torium
20 West Street
Dorking
Surrey
RH4 1BL
UK
Tel: 01306 898144

www.gilliangladrag.co.uk
Worldwide shipping available

For Further Reading and Information on Feltmaking:

Carnival of Felting by Gillian Harris
Complete Feltmaking by Gillian Harris

International Feltmakers Association – www.feltmakers.com

First published in the United Kingdom in 2014 by
Collins & Brown
10 Southcombe Street
London
W14 0RA

An imprint of Anova Books Company Ltd

Copyright © Collins & Brown 2014
Text and pattern/project copyright © Gillian Harris 2014

ISBN 978-1-90939-739-2

A CIP catalogue record for this book is available from the British Library.

10 9 8 7 6 5 4 3 2 1

Reproduction by Rival Colour Ltd, UK
Printed and bound by 1010 Printing International Ltd, China

Photography by Holly Jolliffe

This book can be ordered direct from the publisher at
www.anovabooks.com